Doctors' Work

Doctors' Work
THE LEGACY OF SIR WILLIAM OSLER

Ted Grant

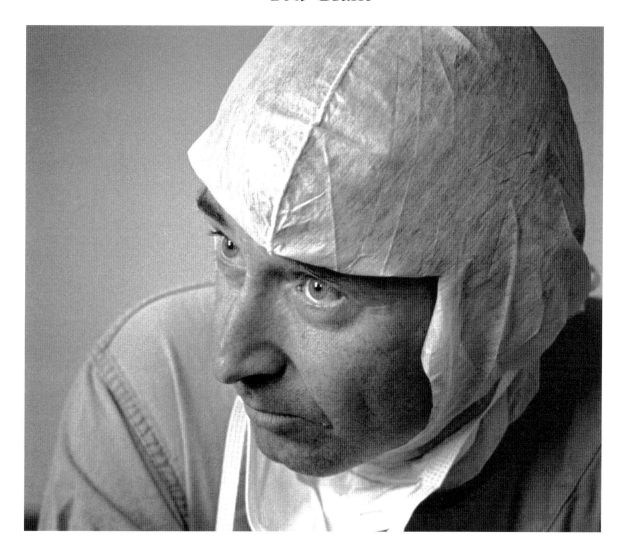

FIREFLY BOOKS

A FIREFLY BOOK

Published by Firefly Books Ltd. 2003

First printing

Publisher Cataloging-in-Publication Data (U.S.) (Library of Congress Standards)

Grant, Ted.
 Doctors' work : the legacy of Sir William Osler / Ted Grant. — 1st ed.
[256] p. : ill. , photos. ; cm.
Includes index.
Summary: A profile of William Osler and a photographic tribute to modern healthcare professionals.
ISBN 1-55297-603-3
1. Osler, William, Sir, 1849-1919. 2. Physicians. I. Title.
610.92 B 21 R464.O85G73 2003

National Library of Canada Cataloguing in Publication Data

Grant, Ted, 1929-
 Doctors' work : the legacy of Sir William Osler / Ted Grant.
Includes index.
ISBN 1-55297-603-3
 1. Grant, Ted, 1929- 2. Medicine and art. 3. Medicine—Pictorial works. 4. Photography, Artistic. 5. Osler, William, Sir, 1849-1919—Quotations. 6. Medicine—Quotations, maxims, etc.
I. Title.

R464.O8G72 2003 779'.961092'092 C2003-900410-4

Published in the United States in 2003 by
Firefly Books (U.S.) Inc.
P.O. Box 1338, Ellicott Station
Buffalo, New York 14205

Published in Canada in 2003 by
Firefly Books Ltd.
3680 Victoria Park Avenue
Toronto, Ontario, M2H 3K1

The Publisher acknowledges the financial support of the Government of Canada through the Book Publishing Industry Development Program for its publishing activities.

Printed in Canada by Friesens, Altona, Manitoba

This book is dedicated to my grandchildren:

Kyle D., Christopher, Kyle G., Katie, Matthew,

Sasha, Terra, Scott, Jamie and Emily.

May they be blessed by

the legacy of Sir William Osler.

Acknowledgments

Grateful appreciation is extended to:

Holly Allen, Everdina Bawtinheimer, Michael Baxter, Doug Beach, Brien Benoit, Pat Bey, Lorraine Billehaug, Jean Bishop, Suzanne Burney, Harvey Carter, David Clarke, Wade Collins, Richard Cruess, J. Cullinan, Serge Curuvija, Joseph D'Alton, Gillian Daniel, Donna Dinnison, Diana Pina, Cec Dinsdale, Tony Dobell, Fiona Donald, Jim Dutton, David Edgel, Jean Elliott, Mary Eng, Andrea Ernst-Bissinger, Julie Farrell, Pat Faulker, Jane Frank, Janet Frechette, Monica Freitag, Pam Genik, Ana Gabor, James Gibbons, Mary Gilmore, John Girling, Sandra Grant, Laurence Green, Geoff Hall, Debbie Havill, Dominique Heon, Carol Hirst, Pat Holmes, Ed Horn, James Houston, Pat Hudson, Phil Huggett, Bridget Ittah, Liz Izmirian, Remi Josie, Mauce Kenny, Wilber Kilshaw, Bruno Kisiel, Boleslaw Lach, Jan Larivière, Susan Leacock, Verna Lloyd, Dick Lurie, Charlotte Macdougall, Eleanor Mack, Paul Marcotte, Jennifer Marler, Ann Mazuruk, Darlene McLennan, Linda Moll, Carmen Moore, Lori Moore, Janice Murphy, Sandy Mynahan, Janet Nelson, Jonah Odin, Annette O'Hearn, Sue Olive, Malcolm Orr, Marjorie Payne, Andy Piers, Adele Quarrington, Mary Raguz, D. Rappaport, Neville Russell, Elizabeth Schneider, Atul Sharma, Roberta Sonnino, Michael Stanger, Christo Tchervenkov, Chantel Therien, Ants Tol, Kathryn Treehuba, Steve Trehan, Norman Wale, Stephanie Wilson, Bruce Yoneda.

Deep appreciation and thanks are also extended to to the following hospitals:

Royal Jubilee Hospital, Victoria, British Columbia
Victoria General Hospital, Victoria, British Columbia
Jasper Seton General Hospital, Jasper, Alberta
Toronto General Hospital, Toronto, Ontario
Ottawa Civic Hospital, Ottawa, Ontario
Montreal Jewish General Hospital, Montreal, Quebec
Montreal General Hospital, Montreal, Quebec
Montreal Children's Hospital, Montreal, Quebec

CAMERAS

The photographs were taken with the German manufactured LEICA single lens reflex and LEICA M6 range finder cameras. These particular cameras are the quietest and least distracting of any in the world and assist the photojournalist to work in an unobtrusive manner, while taking his or her pictures.

No flash was used in any situation and the film was exposed only by the existing available light. In some cases the light level was so low, I jokingly referred to it as "available darkness."

Ted Grant
Victoria, British Columbia

To prevent disease,
to relieve suffering
and to heal the sick —
this is our work.

Sir William Osler

CONTENTS

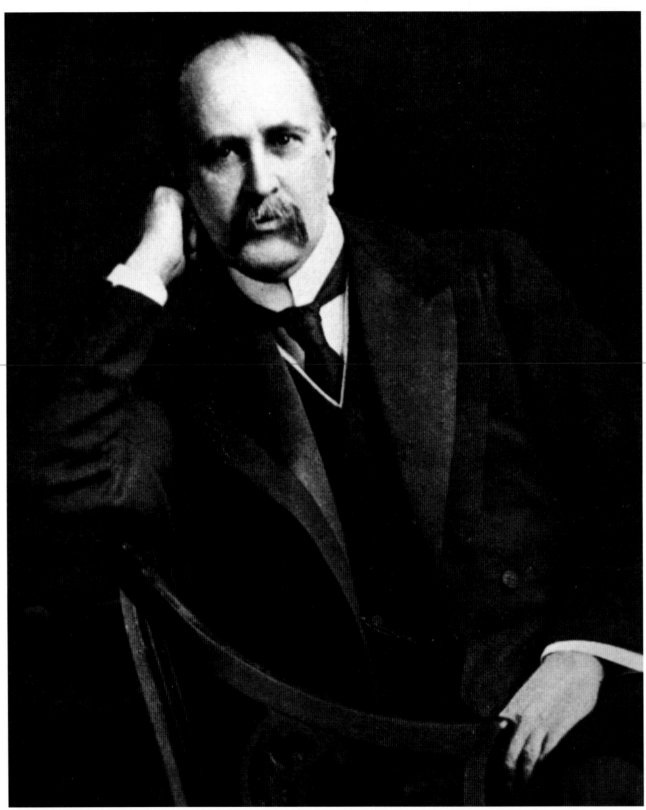

Sir William Osler; 1902.

Sir William Osler, 1849–1919

Foreword

THERE IS ONE PERSON who exemplifies modern medicine as it is known throughout the world, and that is Sir William Osler.

A Canadian by birth, Osler became highly regarded internationally through his chosen profession. Educated at the University of Toronto and having worked in his youth as a professor at McGill University in Montreal, he went on to teach at the University of Pennsylvania before becoming the first physician-in-chief of Johns Hopkins Hospital in Baltimore. World renowned for his textbook of medicine and his clinical skills, he later was appointed regius professor of medicine at Oxford University.

His writings, both medical and philosophical, have been translated into more than 20 languages and emphasize the dedication and self-discipline required to practise the healing arts. No one else in the field of medicine has so profoundly influenced the physician's attitude about the responsibility and dedication inherent in this profession.

Accompanying most of the photographs in this book are quotations from Osler that have served to inspire physicians the world over. Like all great literature, Osler's writings recognize a universal body of knowledge about how the human species should act one toward the other.

James W. Dutton, M.D.
FRCS (C), FACS, FICS
Cardiac Surgeon
Victoria, British Columbia

THE PRINCIPLES AND

PRACTICE OF MEDICINE

DESIGNED FOR THE USE OF
PRACTITIONERS AND STUDENTS OF MEDICINE

BY

WILLIAM OSLER, M. D.

FELLOW OF THE ROYAL COLLEGE OF PHYSICIANS, LONDON
PROFESSOR OF MEDICINE IN THE JOHNS HOPKINS UNIVERSITY AND
PHYSICIAN-IN-CHIEF TO THE JOHNS HOPKINS HOSPITAL, BALTIMORE
FORMERLY PROFESSOR OF THE INSTITUTES OF MEDICINE, MC GILL UNIVERSITY, MONTREAL
AND PROFESSOR OF CLINICAL MEDICINE
IN THE UNIVERSITY OF PENNSYLVANIA, PHILADELPHIA

NEW YORK
D. APPLETON AND COMPANY
1892

Osler's great textbook profoundly influenced the teaching and practice of medicine.

SIR WILLIAM OSLER
A Profile by Douglas Waugh, M.D.

Introduction

RENOWNED FOR HIS great personal charm, prodigious energy and outstanding ability, Sir William Osler had a profound impact on the field of medicine. He was a teacher who demonstrated a powerful affection for his students and a life-long love of books; he was a prolific writer of over 1,500 scientific publications; and he was a physician highly respected for his meticulous observation and devout scholarship. But most importantly, William Osler was one of the innovators who propelled nineteenth century medicine into the modern era.

An immense gulf separates the contemporary medical world from the one into which Osler was born a century and a half ago. Medical practice and education in the 1800s were a far cry from today's high-tech, scientific system of medical care. As Kenneth M. Ludmerer of the Washington University School of Medicine said in 1985:

A century ago, being a medical student in America was easy. No one worried about admission, for entrance requirements were lower than they are for a good high school. Instruction was superficial and brief. The terms lasted only sixteen weeks, and after the second term the M.D. was automatically given, regardless of a student's academic performance. Teaching was by lecture alone. Thus, students were spared the onerous chores of attending laboratories, clinics and hospital wards. Indeed, except for the enterprising and affluent few who would bribe patients into submitting to an examination, students would often graduate without ever having touched a patient. [1]

The few schools that attempted to teach scientific medicine, such as the Medical Department of Lind University in Chicago, the New Orleans School of Medicine, and McGill (Montreal) and Toronto in Canada, were just that – exceptional.

A great many medical schools were also privately owned, and operated for profit and without university affiliation and, thus, without university standards of scholarship. Given the deplorable state of medical education, physicians often had little to offer their patients other than sympathy and tender care for ailments they lacked the means to cure. It isn't surprising then that the medical profession was held in low regard by the general public.

The appalling medical situation was not so much the result of intellectual indolence on the part of the medical profession as it was a reflection of the social climate of the mid-nineteenth century. North America was a place of rapid growth and expansion. Rewards and honours went to the practical men and women who knew how to get things done. There was little recognition and respect for the theoretician and the reflective, speculative thinker.

Nonetheless, there were a small number of people in the medical profession who recognized, and were determined to improve on, their inadequate education. Some students broadened their practical knowledge and skills by apprenticing with practising physicians. The drawback was that while some of the preceptors in these arrangements were outstanding, many were not. Instructors were not required to meet

any established standards, and even if they had been, there were not enough of them to provide advanced training for all of the medical graduates.

Students would also enrol in private extramural medical schools that provided hands-on clinical experience, anatomical dissection and laboratory exercises, or would do service as hospital house pupils (that is, interns or residents), taking responsibility for patient care under the supervision of hospital medical staff. Unfortunately, such programs were informal and optional at best, and none were subject to any prescribed requirements or accreditation. There was always the risk that a student embarking on a program of enhanced training might simply become expert at inappropriate or even dangerous acts of therapy. Finally, there were a few graduates who were affluent enough or sufficiently motivated to study in Europe in order to improve their knowledge of medicine.

The impact of scientific progress can be most readily charted in military medicine. World War I was the first conflict in which casualties from enemy action exceeded the number of deaths from disease.

In France the techniques of observation, recording and counting, rather than experimentation, were the basic tools in the study of disease. As there is often a temporal discrepancy between the doers and the thinkers, it took nearly a century for the American Society for Clinical Investigation to be formed in 1908. Although medical education and practice were backward by world standards, the ferment of change had begun, and some of the most superb clinicians in North America made their appearance. They were physicians so astute in the analysis of a patient's history and physical findings that they were able, with remarkable accuracy, to diagnose the anatomical causes of a patient's disordered physiology. William Osler was this kind of physician, and it was his remarkable ability as a clinician coupled with erudition and personal charm that made him such an influential figure in the advancement of medicine in the Western world. Within the space of a single lifetime, he helped change medical schools from mercenary trade schools into intellectually demanding academic institutions.

Ted Grant has captured on film both the science and the compassion of the new world of modern medicine that came into being as a result of the inspiration, leadership and persuasive personalities of the medical giants a century ago. One of these giants was Sir William Osler, and it is, indeed, a remarkable heritage.

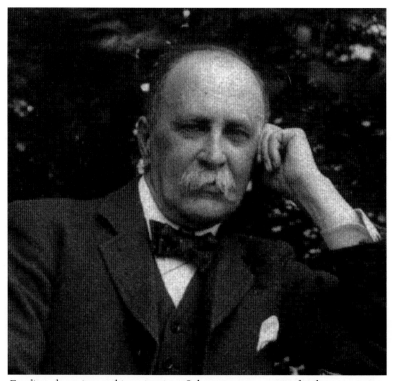

Erudite, charming and imaginative, Osler was a persuasive leader.

The Early Years

THE TINY HAMLET of Bond Head, Ontario, Canada, where William Osler was born, cannot be found in contemporary atlases. It was about two-thirds of the way between Toronto and the southeast arm of Lake Simcoe. Osler père, Featherstone Osler, was a Cornishman who, after a short career in the Royal Navy, retired to become an Anglican clergyman. He married Ellen Pickton and in 1837 migrated to Canada to accept a posting with the Anglican church in the isolated community of Bond Head. After an initial period of real hardship, the young couple managed to build a house. From there the Rev. Osler ministered to a huge parish which extended northward to Penetanguishene and southward as far as Thornhill. It was a distance of more than 60 miles of rugged, sometimes almost impassable, roads and trails which he had to traverse on horseback.

The couple's eighth child, William, was born on July 12, 1849. Although the population of Bond Head was only 200 at the time, there was a doctor, Orlando Orr, who was available to oversee the birth. Ellen Osler raised her brood with a firm hand. Early schooling took place in a nearby one-room log schoolhouse, later replaced by a larger building. The teaching of the three R's was provided by members of a neighbouring family, supplemented by regular instruction from Ellen Osler. Like many of the isolated rectories in the 1800s, this one had a fine library from which to augment the children's education.

The Osler kids had lots of free time in which to indulge their curiosity, to explore the nearby wilderness and to get into mischief – at which they all, and especially Willie, were particularly adept. When William was eight years old, his father was transferred to the more sedate and settled rectorship of Ancaster and Dundas. Featherstone Osler was to remain in these picturesque surroundings for 25 years, among friendly and cultivated neighbours and with access to good schools.

By now, young Willie was a boisterous, rollicking boy, popular among his peers but often the bane of his teachers because of his ingenious practical jokes. It is not clear whether it was the time when a flock of geese was found in the schoolroom, or when all the desks and benches had been unscrewed from the floor and hoisted into the garret, that led to the expulsion of Osler and four of his accomplices from the school. Osler's penchant for practical jokes was to be a lifelong predilection which he eventually learned to channel along more socially acceptable lines.

The following year, Willie was sent to boarding school in Barrie, on the western arm of Lake Simcoe.[2] Harvey Cushing, Harvard's great neurosurgeon and Osler's biographer, describes the young Willie as a child who had no difficulty with scholarship, who excelled in sports and was affectionate, chivalrous and generous – the kind of boy who makes friends fast and is a natural leader.

When a new school was opened by the Rev.

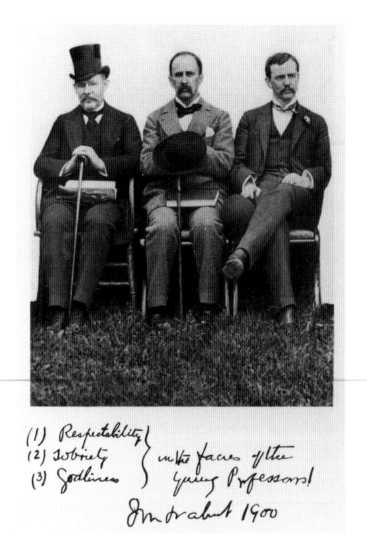

(1) Respectability
(2) Sobriety
(3) Godliness
} in the faces of the young Professors!

Jm dr about 1900

Osler was easily disposed to finding humour in the mundane or unexpected. The caption is by Osler himself – he is in the middle.

of Osler's boyhood companions:

> It was our greatest treat when "Old Johnson" could be led to take a squad out for a field day, hunting fossils, and he did not need much persuasion…. Osler, however, was the scientist of the expedition. To him was entrusted the delicate work of grinding down and mounting specimens for microscope slides.

Jarvis would generate in Osler an interest in science that was to be the first step in a life-long career.

The school thrived, became affiliated with Trinity University in Toronto and was renamed Trinity College School for Boys. Dr. James Bovell, a close friend of Johnson's, very soon became the school's medical director and proved to be an even more powerful influence on the young Osler.

Modelled after English public schools such as Eton, Harrow and Rugby, Trinity maintained discipline through a prefect system. Osler soon became the head of the school's four prefects and was expected to appear in public wearing a top hat. Willie was now a very impressionable 17-year-old.

Oddly enough, it was during his time at Weston that Osler got into serious trouble. There was a housekeeper in the school who was cordially hated by the boys. One day she left a bucket of slops on a stairway, and one of the boys tripped over it and was soused. Reprisal for this was organized by Osler, who arranged to have the old woman barricaded in her room. The boys then concocted a paste of molasses, mustard and pepper which they placed on the schoolroom stove. Smoke and fumes rose into the imprisoned matron's room through the heat

William Johnson in Weston, west of Toronto and closer to the family home in Dundas, William was sent there. Johnson was to become Osler's guide, philosopher and valued friend, and it was from him that Osler acquired his curiosity about natural phenomena and learned the meticulous techniques for the collection and preservation of specimens from fields and ponds. Johnson's influence on the eager young minds in his charge is well illustrated in the following account by the Rev. Walter Jarvis, one

ventilator hole in her floor. When the boys used pointers to dislodge the clothing their victim had stuffed into the hole, she sat on the vent, only to become a target for further pointer pokes from below. Eventually she was rescued by the headmaster, and the boys were duly disciplined with hickory canes.

The matron was not satisfied though. She insisted that charges be laid for assault and battery. As a result, nine boys, including Osler and Warden Johnson's two sons, spent a few days in the Toronto jail. When brought before the magistrate, they were fined a dollar and costs and given a reprimand. It is interesting to speculate whether a student with a record of expulsion and imprisonment would today be accepted for admission into medical school. The paths to glory can be quite circuitous.

At this stage in his life, Osler had set his sights on a career in the Anglican ministry. He went up to Trinity College in Toronto, which was regarded as the nursery for the divinity faculty. Gradually, however, under the continuing influence of Bovell, his interest shifted from divinity to medicine. Thus in the spring of 1868, when he was 19, he wrote to his cousin: "I attend the medical school every afternoon.... I am at Dr. Bovell's every Saturday and we put up preparations for the microscope." It was in the fall of 1868, when he returned to Trinity for his second year in arts, that he announced to his parents and the provost that he had decided to go into medicine.

As a medical student at the University of Toronto, Osler haunted the dissecting rooms of the anatomy department and spent a great deal of time "looking through the microscope at Bovell's cells." These

Teased preparation of fly muscle made by Sir William Osler, c. 1870, when a Toronto medical student.

activities led to his first published work, a short sketch entitled "Christmas and the Microscope," which appeared in a semi-popular English journal devoted to nature study. Osler was now firmly embarked on the methods he would follow for the rest of his life – the act of carefully observing and recording natural phenomena and drawing conclusions from what he saw and measured.

The Early McGill Years

BEFORE HE HAD completed his second year of medical study at the University of Toronto, Osler had decided, on the advice of Dr. Bovell, to transfer to McGill University. The clinical opportunities in the Montreal hospitals were decidedly superior to anything available in Toronto. Before Bovell left for what was to have been a summer holiday in Trinidad, his birthplace, he gave Osler a letter of introduction to Dr. Palmer Howard, then professor of medicine at McGill.

By this time, Osler knew Bovell well enough that he recognized that brilliant though his mentor was, Bovell was interested in so many things that he failed to focus sufficiently on any single pursuit. Thus Osler decided to concentrate his energy and began to formulate the foundations of what would become a personal pattern of work. He would set this forth to his medical students as "the art of detachment, the virtue of method, the quality of thoroughness and the grace of humility" in an address given in 1893 entitled "Teacher and Student." Commenting later on this period in his education, Osler said:

> When in September 1870 he [Bovell] wrote to me that he did not intend to return from the West Indies I felt that I had lost a father and a friend; but in Robert Palmer Howard, of Montreal, I found a noble step-father, and to these two men, and to my first teacher, the Rev. W.A. Johnson, of Weston, I owe my success in life – if success means getting what you want and being satisfied with it.

It was from Thomas Carlyle, the eighteenth century British philosopher, that Osler adopted an idea that became a guiding principle: "Our main business is not to see what lies dimly at a distance but to do what lies clearly at hand." He enlarged on this theme in a speech to students at the Albany Medical School in 1899:

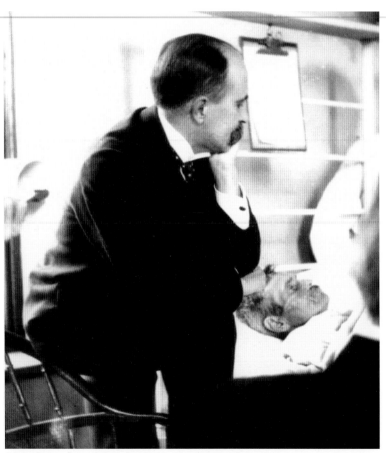

Many hours were devoted to patient and exact observation.

In my school days I was much more bent on mischief than upon books – I say it with regret now – but as soon as I got interested in medicine I had only a single idea and I do believe that if I have had any measure of success at all, it has been solely because of doing the day's work that was before me just as faithfully and honestly and energetically as was in my power.

This dedication to the work ethic was supported and strengthened by Osler's remarkably warm personality. Dr. Fielding Garrison, of the U.S. Surgeon General's office and the biographer of John Shaw Billings, said in 1920:

What made him, in a very real sense, the ideal physician, the essential humanist of modern medicine, was his wonderful genius for friendship toward all and sundry; and, as consequent upon this trait, his large and cosmopolitan spirit, his power of composing disputes and differences, of making peace upon the high places, of bringing about "Unity, Peace and Concord" among his professional colleagues. "Wherever Osler went," says one of his best pupils, "the charm of his personality brought men together." [3]

McGill in the 1870s was undoubtedly the best medical school in Canada. It provided opportunities to students that were unequalled anywhere in North America, with the possible exception of Philadelphia in the United States. Students were given freedom in the wards to meet and examine patients. This privilege was unique in North America and stemmed from the school's Scottish founders in Edinburgh. Other schools, in particular those in

Upper Canada (now Ontario), were modelled on the great London hospitals where ward teaching was much less emphasized.

In addition to his regular studies at McGill, Osler pursued his interests in zoology and general literature and had probably already established his life-long habit of reading every evening. He also added to the animal parasite collection he had started at Weston, and although no publication came out of this work, it was a sustained effort over many years and provided a basis for a continuing correspondence with Johnson.

Johnson urged Osler to introduce himself to J.W. Dawson, F.R.S., the principal of McGill, who, in addition to his primary interest in geology, held the

Osler held that detachment, thoroughness, a solid education in method and humility are essential elements of a good physician.

chairs of botany and zoology. Dr. Palmer Howard was also very influential in Osler's medical studies. Osler said that:

With him the study and teaching of medicine were an absorbing passion, the ardour of which neither the incessant and every-increasing demands upon his time nor the growing years could quench. When I first, as a senior student, came into intimate contact with him in the summer of 1871, the problem of tuberculosis was under discussion, stirred up by the epoch-making work of Villemin and the radical views of Niemeyer. Every lung lesion at the Montreal General Hospital had to be shown to him, and I got [from him] my first-hand introduction to Laennec, to Graves, and to Stokes, and became familiar with their works.... [He was] an ideal teacher because [he was] a student, ever alert to new problems, an indomitable energy enabled him in the midst of an exacting practice to maintain an ardent enthusiasm, still to keep bright the fires which he had lighted in his youth. Since those days I have seen many teachers and have had many colleagues, but I have never known one in whom was more happily combined a stern sense of duty with the mental freshness of youth.[1]

Although he was not the gold medallist in his McGill class, Osler was close to the top and, in Cushing's words, "received at the end of term an honourable mention of unusual sort." When prizes were announced at the graduation ceremony, the statement was made that:

The Faculty has in addition this session awarded a special prize to the Thesis of William Osler, Dundas, Ont., which was greatly distinguished for originality and research, and was accompanied by 33 microscopic and other preparations of morbid structure, kindly presented by the author to the museum of the Faculty.

The thesis was never published.

Osler was now about to begin one of the most illustrious careers of any graduate of a Canadian medical school of his time or since.

Although research and writing occupied much of the young professor's time, he managed to indulge a wide spectrum of interests.

Studies Abroad

OSLER WAS 23 when he graduated, probably about the average age for medical graduates in the early 1900s. Doing what most medical graduates did then, he embarked on a two-year program of study in Britain and on the continent. In those days, students had to finance their own post-graduate training, so it was necessary for Osler to find support. Fortunately, his older brother Edmund, now established in a law practice, was able to provide one thousand dollars, enough to make Osler financially secure for the two-year period.

After short visits to Dublin, Glasgow and Edinburgh, he settled for 17 months in London where he worked in histology (microscopic anatomy) and physiology in the laboratory of Professor Burdon Sanderson. While so engaged, he was able to attend the hospital wards and learn about what he described as "the admirable English system, with ward work done by the student himself the essential feature…. from Ringer, Bastian and Tilbury Fox, I learned too, how attractive out-patient teaching could be made." He would later introduce many features of this system in North America.

It was at this time that Osler began to give serious thought to his ultimate career objective. Bovell had pointed out to him in a letter in September 1872, that "Canada for some time to come must be limited in resources sufficiently remunerative, whereas India, with its teeming population and immense wealth in Native Princes and Merchants affords all a professional man can desire." Osler gave serious thought to this advice but in the end decided that his destiny lay in Canada. Setting his sights on a career in ophthalmology, he thought this field would provide him with a secure income while allowing him sufficient free time to engage in scholarly pursuits; and to prepare himself, he enroled in a program of study in Professor Sanderson's physiology laboratory at University College Hospital in London.

The course of study he chose as a stepping stone to ophthalmology would today be called experimental pathology, although at the time physiology, histology and pathology were combined as a single program under the designation "Institutes of Medicine." In pathology his earlier experience as a microscopist stood him in good stead. But his hopes for a future in ophthalmology were dashed when Palmer Howard wrote him from Montreal to say that three candidates with better qualifications than his had already entered the field. Howard's advice was that he abandon ophthalmology and cultivate instead "the whole field of medicine and surgery, paying special attention to practical physiology." This prompted Osler to write McGill's dean seeking assurance that if he pursued such a course, McGill would be able to provide him a secure future. Appended to Dean Campbell's reply was the information that Principal Dawson was willing to give Osler his lectureship in botany, and he could also teach a three-month course in pathology involving use of the microscope.

There were two problems though. First, there wasn't an endowment for the chair, so the lecturer would have to depend on student fees for financial support; second, Osler believed his knowledge of botany wouldn't be up to the demands of the course. It must have been a tempting proposition to a young man of 23, but Osler had the wisdom and courage to refuse. Instead, he spent ten months "walking the hospitals" – St. Thomas's and University College, where, in addition to seeing patients on the medical services, he attended surgical cases. And using the prize money from his McGill thesis, he enlarged his library with medical texts as well as works by Coleridge and Lamb.

In May of 1873, Osler's paper "On the Action of Certain Reagents – Atropia, Physostigma and Curare – on the Colourless Blood-Corpuscles" was read before the Royal Microscopical Society and later published in the society's quarterly journal. During these investigations, he saw in the blood of patients with a variety of illnesses some peculiar globoid bodies which he thought were bacteria. These bodies had been seen by a few earlier investigators. Their essential role in blood clotting was eventually determined and they came to be called blood platelets. News of his discovery was warmly welcomed when it reached McGill, where Palmer Howard made special reference to it in his introductory lecture at the start of the medical course in October 1873.

On the completion of his studies in London, Osler decided to go to Berlin. There he came under the spell of the two great diagnosticians, Traube and Frerichs, and was extremely impressed by:

the master mind of Virchow [Rudolf Virchow, the founder of modern pathology], and the splendid Pathological Institute which rises like a branch hospital in the grounds of the Charité, that especially attracts foreign students to Berlin. This most remarkable man is yet in his prime (52 years of age), and the small wiry active figure, looks good for another twenty years of hard work.[5]

Virchow was an "ardent politician," active on many committees and an "enthusiastic anthropologist." A man of "comprehensive intellect and untiring energy," Osler wrote, Virchow performed post-mortems with "such care and minuteness that three or four hours may elapse before it is finished."

From Berlin, Osler went on to Europe's other centre of medical interest, Vienna. There, for the first five months of 1874, he filled his time with all the courses he could cram in. Although he found the Vienna experience valuable, he was not as impressed with Vienna as he had been with Berlin. In addition to internal medicine, his studies included otolaryngology, obstetrics and gynecology, and he attended the lectures of the pathologist Carl Rokitansky. Of the pathology, he wrote in a letter: "After having seen Virchow it is absolutely painful to attend post-mortems here, they are performed in so slovenly a manner, and so little use is made of the material." With his remarkably diverse experiences in London, Berlin and Vienna, Osler's chief interest continued to be pathology.

In early April 1874, Osler returned to London to complete in Sanderson's laboratory a paper dealing with his research and to visit friends and relatives. Then having run low on funds, he decided to return to Canada. There weren't any posts immediately available at McGill, so he went once again to Dundas and opened a practice.

From Dundas to McGill

OSLER'S PERIOD IN general practice in Dundas, Ontario, was brief. Perhaps a clue lies in the entry in his account book which reads: "Speck in cornea…. 50¢." Although he remained in Dundas for less than a year, he established a number of close friendships that he maintained all his life. It was not long after he set up practice that he received an invitation from Dr. Palmer Howard, McGill's professor of medicine, to return to his alma mater as a lecturer in Institutes of Medicine, the physiology and pathology course. Howard told Osler he would have to live on the income from his student fees.

In those days, students registered and paid fees to their professors for individual courses rather than, as now, a single fee to the university to cover all the courses. In addition, Howard told him he could hang out his shingle and derive additional revenue from whatever clinical practice he was able to generate. Osler accepted the offer with, as he said, "some diffidence … I am glad it is only a lectureship. It not only sounds better (as I am so young) but to my English friends it will seem more in keeping with what they know of my attainments."

He was expected to give four lectures a week for the winter session. Never having lectured before, he found the prospect a daunting one and accordingly threw himself into the task with all of his energy. Dr. Beaumont Small, one of the students in Osler's first class, wrote about his impressions of the neophyte lecturer:

I saw him first as he entered the lecture-room to open his course on the Institutes of Medicine. Quick and active, yet deliberate in his walk and manner, with a serious and earnest expression, it was evident that he looked upon his lectures as serious, and at once imparted the same feeling to others. In a very few words he welcomed the class, stated what he hoped to do and what he expected in return, concluding with a gentle warning that he expected attendance and attention from all. We succumbed to that genial and kindly manner which has been so characteristic throughout his life and

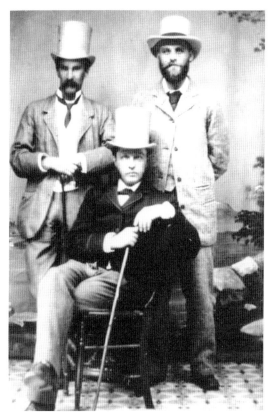

W. Osler, F.J. Shepherd and G. Ross, professors at McGill, 1878.

I doubted if any professor had more carefully studied lectures, or better attention than was given to him.[6]

On March 31, 1875, when he was only 26, Osler gave the valedictory address to the graduating class – his first public presentation of advice to students. The address contains the seeds of his philosophy of teaching and learning. In it he warned students that their education was not, and never could be, complete. Unlike law or theology, medicine is a progressive science, he said, and its practitioners must keep up with it by reading, cultivating books, attending societies and presenting reports. He reminded the students of Sir Thomas Browne's injunction that "No one should approach the temple of science with the soul of a money changer" and then went on to touch on their obligations to the poor.

During the early part of his time at McGill, Osler did not have a hospital appointment although he was eager for the opportunities in the pathological laboratory. It was the custom for visiting physicians and surgeons at the Montreal General Hospital to perform their own autopsies. When Osler volunteered to take on this task, his offer was quickly accepted by many of the staff. In doing so, he adroitly positioned himself for promotion to the position of pathologist should such a post be created.

Osler, still a voracious reader, also started a journal club. The club purchased and distributed periodicals that were beyond the capacity of the pockets of many. Each of the 11 members of the club was required to chip in ten dollars and was rewarded with an expanded variety of reading material.

The demands on Osler's meagre income were severe, especially since he was in the habit of reaching into his own pocket for funds and supplies that were not budgeted for. He explained later that he "suffered from an acute attack of impecuniosity," supplementing his income by taking on the dangerous task of caring for patients in the smallpox wards of the Montreal General Hospital. This work netted him six hundred dollars a year.

In the late 1870s the hospital was only a modest structure of 150 beds. Attached to the hospital was an isolated smallpox ward where members of the hospital staff provided service on a rotational basis. Smallpox had reached epidemic proportions everywhere and was particularly severe in seaports like Montreal. In a 19-month period, from December 1873 to July 1875, there were 260 cases, of whom 24 died.

Using his earnings from his duties in the smallpox ward, Osler bought 12 microscopes for his students' use and made McGill the first university in the country to provide facilities for such a course in the Institutes of Medicine.

Although he thought he was immune to smallpox, Osler did eventually suffer a mild and attenuated attack because the vaccinations he received had failed to take. It was an incident he was fond of citing later as evidence that failure of a vaccination to take was not, in fact, evidence of immunity.

In his promotion of medical education, Osler took an active part in revivifying the Medico-Chirurgical Society (the oldest medical society of its kind in North America and the equivalent of today's local medical societies) and became a member of its program committee. An important part of each society's monthly meetings was Osler's presentation

of pathological notes on the cases that were presented for discussion. His enthusiasm in making his presentations inspired many of his listeners with a serious interest in pathological history.

Osler lost little time in immersing himself in a variety of activities at McGill. His curiosity about all things medical was insatiable. In 1874 he was elected to membership in the Natural History Society, and the following year he became a member of the council. In addition to his work in the smallpox ward, he engaged in public health work. About this time, he and several colleagues formed the Microscopical Club, of which he became the first president.

Meanwhile, his activities in the General Hospital's autopsy room yielded pathological specimens that became the basis for a collection which grew into the McGill Pathological Museum. In May 1876 the Montreal General Hospital created the position of pathologist for him, and he lost no time in engaging students to assist him in the collection and preservation of specimens. During the next year there were 100 autopsies, many of which he reported to the meetings of the Medico-Chirurgical Society; these were eventually printed in book form. When medical classes resumed in the fall of 1876, Osler was able to inform the students in his physiology course that they were free to attend autopsies at the Montreal General Hospital.

In addition to all of these commitments, Osler also began visiting veterinarians in order to study and tabulate animal parasites. He was soon appointed as a professor of physiology at the Veterinary College of Montreal and vice-president of the Montreal Veterinary Medicine Association.

In his continuing quest to improve medical education at McGill, Osler, accompanied by two McGill colleagues, Drs. Ross and Shepherd, visited the Harvard Medical School in April 1877 to familiarize himself with its organization and teaching methods. In his account of this visit, Osler's concern over medical pedagogy is evident:

It is a matter for surprise that some of [the] leading colleges in the United States have not followed the

"Learning by doing" remained a guiding principle throughout Osler's professional life. Here he is examining human organs.

good example of Harvard. No doubt it would be accompanied for the first few years by a great falling off in the number of students, and consequent diminution in income, and this in many instances is avowedly the chief obstacle in so desirable a step. One or two of the smaller schools have adopted the graded system and I see by a recent American journal that the University of Pennsylvania has decided to pursue it, though in a modified and curtailed way. These are indications that the medical schools in the United States are being stirred up to some sense of the requirements and dignity of the profession they teach. It is high time. The fact that the Canadian student after completing his second winter session (not even passing his primary) can go to the University of Vermont and I doubt not to many other institutions, spend ten weeks and graduate, speaks for itself and shows the need of sweeping reform.[8]

It is obvious that Osler, now only 28, was already caught up in the movement to reform and improve medical teaching – a movement whose early stages were not manifest in the initial steps to organize the unique educational program of the Johns Hopkins Hospital and Medical School.

It was also through Osler's influence that the McGill Medical Society was organized in 1877 for the benefit of medical undergraduates. Dr. Beaumont Small, reporting on the first meeting of the society, said:

Its object, as defined by himself [Osler] … "was to afford opportunities, which after graduating you never obtain, of learning how to prepare papers and express your ideas correctly, while your meetings will also secure for you a training in the difficult science of debate." … A literary character was often imparted to the meetings by the reading of short selections from notable authors ranging from Shakespeare to Dickens.[9]

Osler's ability to engage others in the enthusiastic pursuit of his current interest was an aspect of his character that was becoming increasingly evident – many were willing to work for and with him. His demands were virtually unlimited, but his willing helpers were amply repaid in the opportunities provided for instruction and good fellowship. His ebullient enthusiasm was catching. Always cheerful, he never lost an opportunity to offer words of encouragement to those who worked with him.

At this stage in his career, Osler was already becoming a prodigious writer. From a contemporary perspective, when the handling and processing of information are so greatly facilitated by innumerable machines, it is difficult to see how Osler, without such advantages, could have accomplished so much at such an early age, even acknowledging that others helped him. For example, in the years 1877 and 1878 he published no fewer than 49 articles and reports – almost one every two weeks. It is truly remarkable that he was able to find time to do anything but write.

But find time he did. In 1878 he produced one of the earliest descriptions of the condition now known as hog cholera; wrote and passed the membership examinations for the Royal College of Physicians of London; studied and reported the phenomenon of transient strokes (now called transient ischemic attacks); introduced the teaching of comparative pathology (the study of diseases in different animal species) and bedside teaching at the Montreal

General Hospital; and presented numerous papers at meetings in North America and abroad. And these are just the highlights of his life. He still found the time to engage in animated discussion with students and colleagues and to indulge his reading interests.

This heavy workload, though, did nothing to inhibit his sense of humour. It was at this time that Osler began what was to become a long-standing practical joke in medical literature. He prepared an article entitled "Professional Notes among the Indian Tribes about Gt. Slave Lake, N.W.T." and signed it Egerton Y. Davis, M.D., Late U.S. Army Surgeon. This was a pseudonymous dissertation in Rabelaisian tone on alleged tribal rites of the Indians of the Northwest. The article was actually accepted by the *Canada Medical and Surgical Journal,* where it would have been printed had not Osler, on seeing it in the printing office, scribbled across the title page "Joke on Molson – W.O." Dr. W.A. Molson was the journal's editor. More peculiar "scientific" publications from Dr. E.Y. Davis followed in the ensuing years.

It should come as no surprise that Osler finally became so loaded with responsibilities that he protested. As was characteristic of him, he did not do this in the usual manner of writing a letter to the dean or principal but rather by communicating the problem as a general concern for all of academic medicine. He wrote in the *Canada Medical and Surgical Journal* in 1884:

It is one thing to know thoroughly and be able to teach well any given subject in a college, it is quite another thing to be able to take up that subject and by original work and investigation add to our stock of knowledge concerning it, or throw new light upon the dark problems which may surround it. Many a man, pitchforked, so to speak, by local exigencies into a professional position has done the former well, but unless a man of extraordinary force, he cannot break the invidious bar of defective training which effectively shuts him off from the latter and higher duties of his position.… The instances are few indeed in our universities in which a professor has but a single subject to deal with, and those which do exist are in the subjects of great extent and often subdivided in other colleges.… If Canadian scholarship is to be fostered, if progress in science is to be made, this condition of things must be remedied, and we may confidently hope will be, as years roll on.… But unless the liberality of individuals is manifested in the manner of the late Mr. Johns Hopkins of Baltimore, we shall have to wait long for a fully equipped Canadian University.

He appears to have been reacting to his own overload of responsibilities when he decided to break "from the drudgery of teaching" by spending the summer of 1884 in Europe. In the course of his travels, he renewed his contacts with Virchow, Robert Koch and several other prominent European physicians and sent regular reports on his observations of European medicine to the *Canada Medical and Surgical Journal.*

It may have been that the stress of overwork made him more willing than he might otherwise have been to accept an offer of the chair of clinical medicine at the University of Pennsylvania in July 1884. In any case, "the offer played the deuce with my peace of mind," he wrote. As he recalled many years later:

I sat up late into the night balancing the pros and cons of Montreal and Philadelphia.... I finally gave it up and decided to leave it to chance. I flipped a four-mark silver piece in the air. "Heads I go to Philadelphia; tails I remain at Montreal." It fell "heads."

Neither McGill nor the Canadian Medical Association was willing to let him go without a struggle. The association elected him president the following year, and McGill sought to entice him with the offer of a newly created chair in pathology.

Without a doubt, the offer from Philadelphia marked the turning point in Osler's career. He was now 35, with a long list of important accomplishments. Up to this point, his career had been largely based on his work in the pathology laboratory, with his only significant clinical experience being in the smallpox wards. It may be that, as Cushing speculates, he now became aware that his true inclination lay in the study of disease at the bedside rather than in the laboratory.

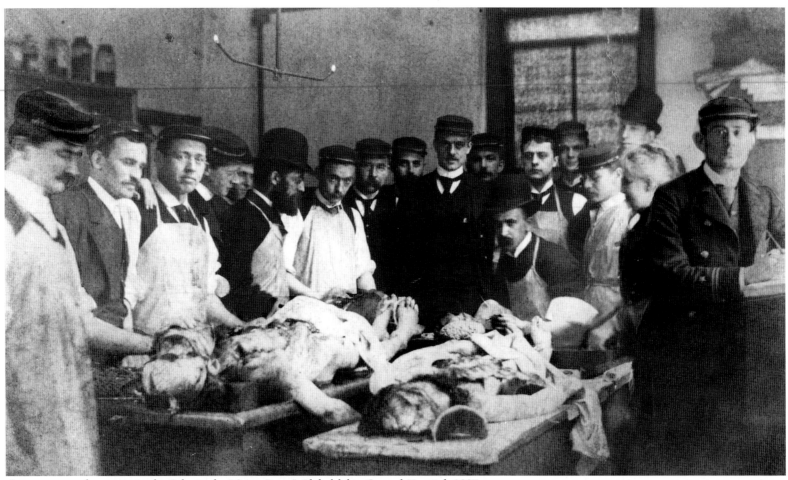

A post-mortem demonstration by Osler in the "Green Room"; Philadelphia General Hospital, 1887.

Philadelphia

B Y THE TIME Osler moved to Philadelphia, he was recognized as a very able young physician with the mark of greatness already upon him. It was his time in Philadelphia, and subsequently his career at Johns Hopkins and Oxford, that established him as the medical leader of the English-speaking world. Unlike many who have made their reputation in the field of science, Osler not only became increasingly expert in one or two areas of his field, but was also able to draw people to him and persuade his students and peers to emulate his voracious interest in medical education, his profound scholarship, his diagnostic acumen and his urbanity.

Philadelphia students who first encountered him in the lecture theatre were not impressed by his oratory. According to Cushing, Osler did not give the "polished declamations and glowing word-pictures"[10] that students were accustomed to hearing from other teachers at the school. Osler appeared before them a swarthy man with halting speech who insisted on presenting to them a patient exhibiting the manifestations of the disease under discussion. However, when students encountered him at the bedside in the hospital wards they became impressed with his enthusiasm, his curiosity about the illnesses of his patients, his erudite allusions to classical as well as medical literature, and his insistence on relying on laboratory analyses. Perhaps as important as any of these qualities was the sense of humour in Osler's presentations. He could find amusement in almost any situation and would poke fun at himself as readily as at others.

Osler brought new ideas and enthusiasm to the medical school in Philadelphia, and the school itself provided fertile soil in which the seeds of his ideas could grow. Following in the footsteps of Harvard, the University of Pennsylvania Medical School made a three-year undergraduate course obligatory. It was also one of the first schools in North America to have an entrance examination. Notwithstanding the early circumstances surrounding his appointment, there were in the faculty, in Cushing's words, "waves of regret and indignation" at his appointment. Osler seems to have ignored them and entered the faculty with a natural grace that made it difficult for any organized opposition to develop. His entry was doubtless eased by the fact that he chose to limit himself to a consultant practice, seeing only patients referred to him by other physicians; consulting was rarely done at the time.

Although he bore no formal title during most of this period, Osler was functioning as a pathologist, building on his experience of more than 700 post-mortems in Montreal. On one occasion he cheerfully demonstrated to his students that he had diagnosed a case of croupous pneumonia; at post-mortem, the patient was found to have suffered from a chest full of fluid. During the four years he was a member of the Pathological Society of Philadelphia, he appeared on its program 52 times. There are hand-

written records of the 162 autopsies he performed in the pathology department.

One of the diseases Osler was studying was malaria. On the basis of his microscopic studies of the blood from malarial patients at various times in the evolution of their disease, he was able to present to the Pathological Society, and later publish, the results of this work.[11] This report placed Osler in the front rank of investigators of *Plasmodium malariae*.

In Philadelphia he continued to promote both formal and informal communication among physicians, mainly through the formation of clubs and societies devoted either to particular fields of interest or to the exchange of information on scientific advances of general interest; and he maintained an active role in the Canadian Medical Association (of which he became president in 1885). He was also one of the founders of the Association of American Physicians and wrote many years later that the "Association set a standard, promoted good fellowship, encouraged research among the younger men, and has led to the formation of many societies dealing with various aspects of medicine and pathology."

It was characteristic of Osler that in an era of considerable formality, he tended to ignore some of the social niceties. He would drop in on his friends unannounced, play games with their children and act like a member of the family. He had an unusual gift of empathy, and most of his acquaintances considered him a close friend.

Osler also continued publishing reports on such diverse topics as diseases of the appendix, smallpox, the physiology of the blood, anemia, malaria, brain tumours and typhoid, as well as writing innumerable editorials for the *Medical News* and book reviews for the *American Journal of Medical Sciences* and other journals. In the year 1887 alone, he published more than 80 papers. By now he was recognized as one of the most prolific medical writers in the English language.

Until this time, Osler had had a limited social life. Apart from informal meetings with his medical colleagues and students, and occasional visits with his friends and relatives, his work was his life. Meanwhile, the university in Baltimore had been left money by the wealthy merchant Johns Hopkins and was beginning to explore the idea of establishing a medical school. The Johns Hopkins' trustees had retained John Shaw Billings of New York and Washington as their advisor on the establishment of the school and the recruitment of faculty. Writing of this much later, Osler said:

An important interview I had with him [Billings] illustrates the man and his methods. Early in the spring of 1889 he came to my rooms, Walnut Street, Philadelphia. We had heard a great deal about the Johns Hopkins Hospital, and knowing that he was virtually in charge, it at once flashed across my mind that he had come in connection with it. Without sitting down, he asked me abruptly: "Will you take charge of the Medical Department of the Johns Hopkins Hospital?" Without a moment's hesitation I answered: "Yes." "See Welch about the details; we are opening very soon. I am very busy today, good morning," and he was off, having been in my room not more than a couple of minutes.

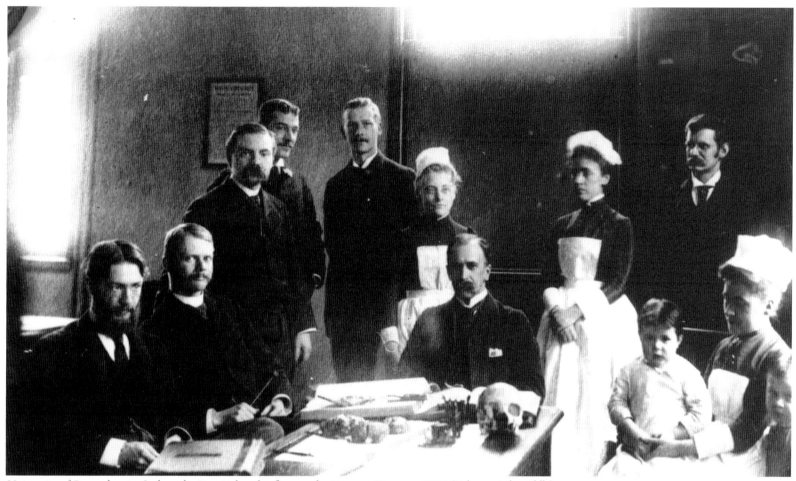

University of Pennsylvania Orthopedic Hospital and Infirmary for Nervous Diseases, 1887 (Osler seated, middle).

Many of Osler's friends and colleagues were very saddened to see Osler leave Philadelphia. "He is one of the most popular men I ever knew. It is extraordinary what a hold he has on the profession in Philadelphia," wrote Dr. H.P. Bowditch of Boston, who spoke at a farewell dinner organized by the faculty. The news of Osler's departure also created a great stir in medical education circles throughout North America, where the evolution of Johns Hopkins was being watched with wary interest.

Thus Osler came to make a second decisive move in his medical career, going, as we shall see, from strength to strength.

Johns Hopkins

T O FULLY appreciate the reform of medical education that took place at Johns Hopkins, it is necessary to review the changes that were occurring elsewhere. As we have seen, medical education in North America during the first half of the nineteenth century was generally inferior, usually consisting of two 16-week courses of lectures, on the completion of which students were given a cursory examination and handed their degree.

Charles W. Eliot, chemist-president of Harvard University, began the reform of medical education in America. In the early 1870s Eliot persuaded the medical faculty to become an integral part of the university, to adopt a course of instruction consisting of three nine-month terms and to introduce a structured curriculum in which students were exposed to laboratory experience in the basic sciences prior to their instruction in clinical medicine. By 1880 the school had added a fourth optional year which, soon afterward, became mandatory.

Following Harvard, the University of Pennsylvania, the oldest medical school in the United States, adopted a more rigidly prescribed curriculum. By 1882 the terms had been lengthened from five to six months and a voluntary fourth year was added in 1883. (It would become mandatory ten years later.) Osler, on

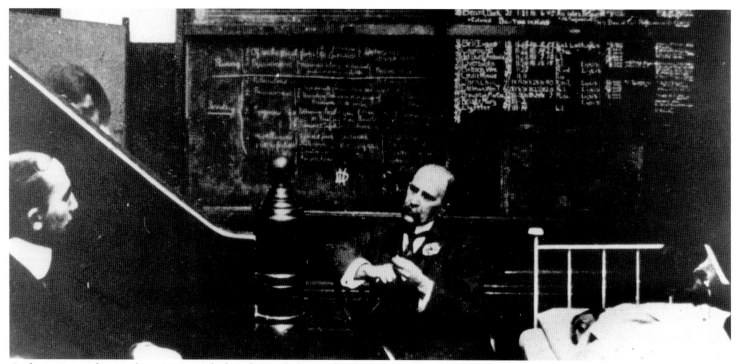

Student quiz at Johns Hopkins, 1902; on the board is a tabulation of typhoid and pneumonia cases.

the faculty of Philadelphia around this time, was involved in the radical revisions of the medical curriculum there.

When Johns Hopkins died in 1873, he bequeathed a sum of seven million dollars to be equally divided for the founding of a university and a teaching hospital. Under the guiding hands of two interlocking boards of governors and with the advice of Dr. John Shaw Billings, construction of the hospital began in 1877 and was not completed until 12 years later. It was to this hospital that Osler came in 1889. As chief of medical services, he would prepare the way for the first class of students to enter four years later. (Graduate courses in pathology had been under way since 1886, under Professor William Welch.)

The most spectacular innovation in the history of American medical education took place with the opening of the Johns Hopkins Medical School. Candidates for admission had to possess a bachelor's degree. The first two years of instruction were in the basic sciences, followed by two years of rigorous training in clinical subjects where the focus was at the patient's bedside. A true university atmosphere pervaded the school, which saw research as its primary mission and the training of investigators as well as practitioners as its goal.

With its new hospital, huge endowment and true university affiliation, Johns Hopkins became the first genuine graduate university in the United States. Dr. John Shaw Billings, the special advisor on medical education and hospital organization, was probably the most versatile physician of his period. He designed the hospital, articulated the school's educational philosophy and oversaw the selection of faculty. William Welch, the school's first dean, described Billings as "the wisest man I ever knew." [12]

The school's founding fathers had an advantage over reformers at other schools: they were starting from scratch, without an entrenched and hostile faculty. There were, nonetheless, skeptics in the world of medical education who doubted whether such a radical structure could attract sufficient numbers of students.

It was at Johns Hopkins that bedside teaching became standard practice for all medical students.

During his time at Johns Hopkins, Osler never let up on what he called his "ink pot career" – his writing and sermonizing about the art and practice of medicine. He was in demand as a lecturer, and most of his lectures were published. As well, he continued to publish clinical and pathological reports and write sections for Pepper's *System of Medicine*. He also made many contributions to the Pathological Society and wrote editorials, notes and book reviews for the *Medical News* and the *American Journal of Medical Sciences*.

Before the arrival of the first class of students, Osler embarked on his greatest written work – *The Principles and Practice of Medicine*. He had long recognized the need for a new textbook of medicine since existing English language tomes were badly out of date, badly written or both.

With his journal club experience and his regular writing of reviews of textbooks and journals, Osler was exceptionally up to date on most of the new medicine. By now he had also polished his literary skills. And his background in pathology gave him a perspective on the practice of medicine that was possessed by few of his peers. To complete his textbook, he followed a rigid routine, rising early and balancing long hours of writing with long hours in the hospital. "During the writing of the work I lost only one afternoon through transient indisposition, and never a night's rest," he said.[13] Appleton, the book's publisher, had guaranteed a sale of ten thousand copies of the book in two years and agreed to pay Osler an advance of fifteen hundred dollars when the book was published.

Within a week of this "glittering" publishing offer in May 1891, Osler was asked by both the universities of Pennsylvania and Harvard if he was interested in their chairs of medicine. Attractive though these invitations were, he turned them both down.

At this time Osler, now 42, became quietly engaged to Grace Linzee Revere, five years his junior and a direct descendant of Paul Revere. The couple was married in quiet informality on May 7, 1891, at St. James's Church in Philadelphia. They travelled to New York and then Toronto, and later sailed to

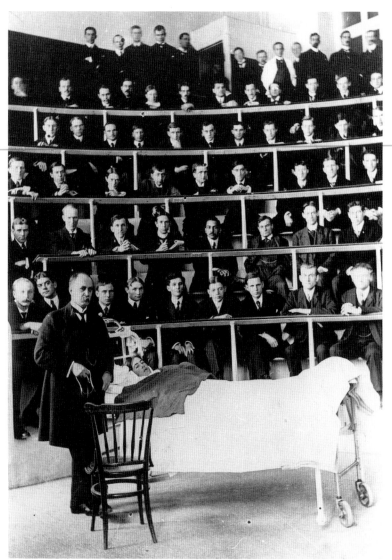

Last clinic at Royal Victoria Hospital; McGill, December 18, 1906.

Britain where Osler attended the meeting of the British Medical Association. Their extended British honeymoon combined social events, where Mrs. Osler was introduced to many of William's old friends, with medical meetings. On their return to America, Osler was once again caught up in a round of visits, lectures and addresses.

The Johns Hopkins Medical School finally opened its doors in 1893, twelve years after the hospital had opened. This long delay was caused mostly by financial difficulties. As we have seen, Osler made good use of the four-year interval between his appointment and the arrival of students by organizing his department, writing his textbook and being actively engaged in medical affairs. In particular, he maintained an active correspondence with his Montreal friends, keeping in close touch with developments at McGill. Indeed, it was taken for granted at McGill that when Principal Dawson retired in 1895, Osler would be named his successor. Osler quickly scotched this rumour, pointing out that "executive work has never been in my line."

Under the influence of Osler, the hospital became an integral part of the medical school with students actively taking part in the care of patients. As clinical clerks, they were responsible, under supervision, for patients' histories, physical examinations, blood and urine examinations, the changing of dressings, and all manner of other tasks. This "learning by doing" aspect of medical education was the real revolution in medical teaching of the nineteenth century. Osler combined the best of the medical education systems he had observed in Britain with the German system of residency training.

Osler remained at Johns Hopkins until 1905, during which time the medical school became firmly established at the forefront of American medical education – a position it continues to hold.[14]

By now his reputation throughout the English-speaking world was such that scarcely a year went by without Osler's being invited to consider a teaching chair. From Harvard came one such offer, "the duties of which are to be invented" – in other words, carte blanche! Once more, Osler declined. Then he was invited to express an interest in the post of regius professor of medicine at Oxford University. Spurred by his deep admiration for Oxford, his interest was immediate and strong. In Grace Osler's words:

> …. [H]e thrust a letter into my hand and placed a finger on his lips to signify I must not exclaim. It was Sir John Burdon Sanderson's letter suggesting his appointment as his successor to the Regius Professorship at Oxford…. I felt a tremendous weight lifted from my shoulders as I had become very anxious about the danger of his keeping on at the pace he had been going for several years in Baltimore.

Osler immediately arranged to see Sir John during a forthcoming visit to Oxford. Uncharacteristically, Osler vacillated over his final decision and was only prodded into action by a cable from his wife, saying: "do not procrastinate. accept at once." After some further exchanges between Osler and the authorities at Oxford, he finally accepted the appointment.

The Oxford Years

WHEN HE ARRIVED at Oxford in 1905, Osler was 56 and at the height of his intellectual powers. His enormous energy, power of concentration and affability enabled him to establish quickly a comfortable rapport with his new, highly refined surroundings and colleagues. One of these men, the Rt. Hon. Herbert Fisher, said of him:

Though Oxford is proverbially hospitable and generous, she does not easily capitulate to strangers, especially if their claim to distinction rests upon scientific rather than on literary grounds, but Osler left Oxford no choice, and from the first the surrender of the University was absolute and immediate. Of course his great reputation as a physician and medical writer had preceded him, but we immediately discovered that finished competence in his own art and science was but a small part of the man, that the new Regius Professor was the least professional of doctors and the least academic of professors, that he was amazingly devoid of vanity and pedantic inhibitions, that his spirit was free, alert, vivacious, and that there was apparently no end to the span of his interests or to the vivid life-giving energy that he was prepared to throw into any task which fell to him to discharge. Old and young alike acknowledged his mastery and never left his presence without feeling the magnetism of the man and that insatiable but unobtrusive appetite for helpfulness which made him the prince of friends and benefactors. [15]

Almost immediately Osler was drawn, quite willingly, into a round of activities and commitments that would have staggered many a younger man. He became an active member of the Bibliographic Society and a curator of Oxford's Bodleian Library; he participated, at a distance, in establishing the Warrington bibliographic collection at Johns Hopkins. He threw himself with his customary enthusiasm into his teaching commitments at Oxford, was involved in the affairs of the Royal Society of Medicine and testified before the Royal Commission on Vivisection. He also found time to establish his Oxford residence, the "Open Arms,"

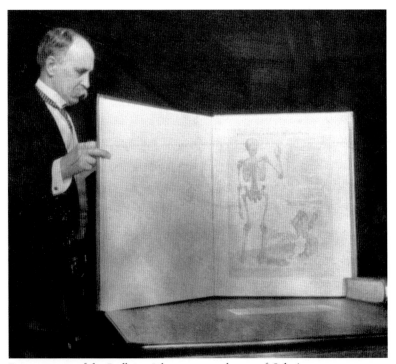

Being curator of the Bodleian Library was only one of Osler's many commitments at Oxford.

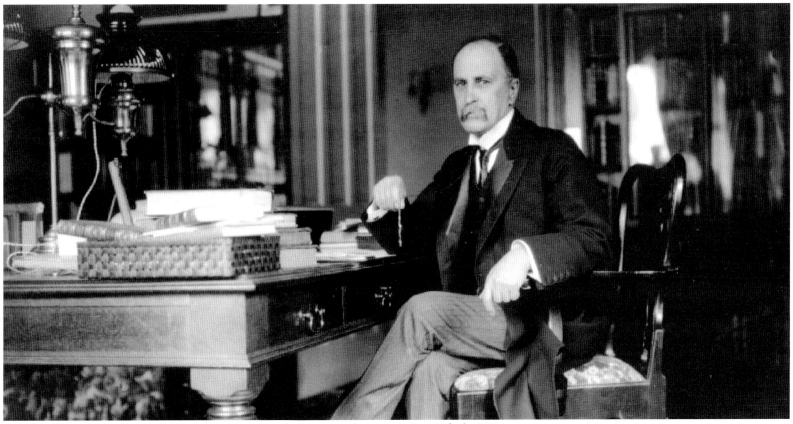

As well as lecturing, writing and editing, Osler maintained a busy consultation practice; Oxford, 1907.

which functioned almost as a small hotel for his frequent visitors from Britain and abroad.

As one of the most famous physicians in Britain, he soon became involved in a busy consultation practice that seemed unaffected by his hefty fees.[16] And during his first few years at Oxford he made at least annual voyages back to North America, where he kept in close touch with his colleagues in Baltimore, Philadelphia, Montreal and Toronto. These activities, together with recurring revisions of his textbook and a commitment to edit and supervise the production of a new *System of Medicine,* must have left him little time for sleep.

Osler was also much in demand as a visiting lecturer both in Britain and on the continent. Although many of his lectures were on medical topics, he presented a number of philosophical dissertations that were almost sermonlike. These were eventually collected and published under the title *Aequanimitas and Other Addresses.* Many are as readable and cogent today as they were when first issued.

Of the many sides to Osler's complex personality, none is more fascinating than his obsession with books, particularly ancient ones. At Oxford, a great deal of his energy was devoted to the preparation of a classified and annotated index of his huge personal library. This *Bibliotheca Osleriana,* as it became known, was conceived during a visit to the Pepys Library at Cambridge University in 1914. He initiated work on the catalogue of his own library in

consultation with Charles Sayle of the Cambridge Library, a task that became his consuming interest during the final five years of his life. Of this effort, he said:

> The merit that appeals to one is a combination of biography with bibliography – beside the book is a picture of the man sketched by a sympathetic hand. Would that in other subjects, students as accurate and as learned could be induced to follow this example.

He studied catalogues of book auctions for rare books relating to medicine and was known to haggle until he had the best price. Where an item was beyond his means, he occasionally sought a book purchase grant from Lord Strathcona, then chancellor of McGill. His enthusiasm for books was expressed eloquently in a letter he wrote from Florence in 1909:

> This place is of overwhelming interest – libraries, pictures, etc. The Laurentian Library is just too splendid for words 7000 chained MSS. All in the putei or cases designed by Michelangelo … The book shops are good. Olschki one of the best in Europe. He has 500 incunabula on the shelves, a Silvaticus a *cuss* of no moment – of 1476 – superb folio, one of the first printed in Bologna – fresh and clean as if printed yesterday & such a page! But he asks 1500 francs!! His things are wonderful but really auction sale is the only economical way to get old books.… I am in a state of mental indigestion from plethora …

The coronation honours list for King George V included Osler as one of 20 newly named baronets.

Commenting on the honour, he wrote in a letter, "They have been putting a baronetcy on me – much to the embarrassment of my democratic simplicity, but it does not seem to make any difference in my internal sensations."

The Oslers' only child, Edward Revere Osler, had been born in Baltimore at the end of 1896. When war broke out in 1914, Revere was just approaching military age, a fact that caused his parents no end of worry. As a student at Oxford, he had become devoted to art and literature and seemed destined to follow in his father's footsteps as a great lover of books.

In January 1915, Lady Osler wrote to her sister:

> Revere has had his 19th birthday and has made up his mind about the first step to take. He simply can't talk

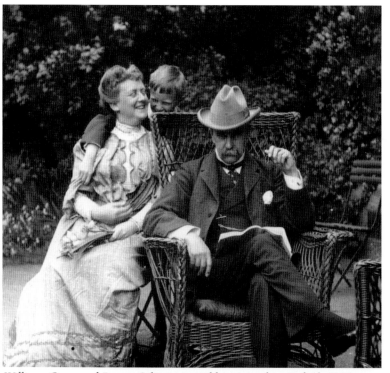

William, Grace and Revere Osler in a neighbour's garden; Oxford, 1905.

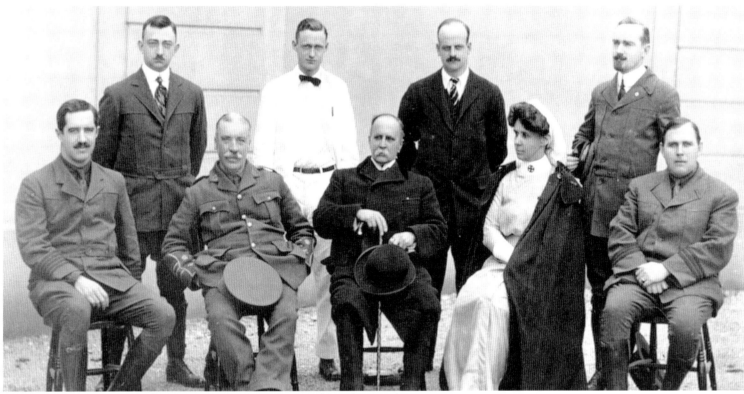

Osler (seated, middle) and staff; American Women's War Hospital, South Devonshire, 1915.

with his father, but talked wisely, oh so wisely with me…. Today he brought home his books from Christ Church [Oxford] and his lovely room must be dismantled. What a strange fate after our fear that he might never get in! So that is done for, and the only hope is that the war may some day be over and he can return … I shall do my utmost to hold out and have a cheerful face for the poor dear unselfish angel who is breaking his heart over giving up his boy to this awful risk.

Revere began his military career as orderly officer to Colonel Birkett, commander of the McGill unit, and then transferred to the Royal Field Artillery. After a period of training in England, young Osler's artillery battery was ordered to France, where it became engaged in heavy fighting. He did not see his parents

again until June 1917, when he returned home on ten days' leave. His father said of him, "He went away a boy and has returned as a hardened man."

On August 29 Lieutenant Osler was helping a crew of 18 men bridge a shell hole when the group was hit by an incoming artillery shell. Revere was severely wounded by multiple shrapnel fragments. Although brought quickly to hospital and given a blood transfusion, the great-grandson of Paul Revere failed to survive the night.

Osler was consumed with grief. But in spite of his sorrow and his advancing age, he maintained a hectic pace of academic life throughout the war years. He eventually persuaded John McCrae of McGill to take on a major role in revising his textbook and added McCrae's name as a joint author of the work.

newspapers such as the *Times*. Although he never admitted the impact that his schedule had on his health, Lady Osler, writing to a friend at about this time, said:

Sir William is thinner than ever, but very brown as he spent two days last week on the roof outside my door.... We had an awful week or ten days with so many near friends ill and injured, and ending by his getting a cold. He went at once to bed with aspirin and a lemonade with hot whiskey – the first I ever knew him to take, and we headed it off.

Even when laid up in bed, Osler would write to friends, give advice to his colleagues in America and do most of the other things he would do when well. His restless mind was rarely still.

In January 1919 he was persuaded, despite his objection that he was already overworked, to accept the presidency of the Fellowship of Medicine, which prompted the *Times* to editorialize:

The choice of Sir William Osler as President is one which the whole profession in America as well as the whole profession in Britain will welcome. An international figure, he has been so closely identified with all that is best in American and Canadian medicine that our friends on the other side of the Atlantic claim him with as much pride as we do. His influence on medical thought during the last two decades has, indeed, been almost boundless, while his *The Principles and Practice of Medicine* has enjoyed a vogue rarely attained by any professional work. Sir William Osler, too, has done more than any man of his time to secure a true perspective in

William and Grace opened the doors of their home, appropriately named the "Open Arms," to frequent overnight visitors and dinner guests; on the terrace, 1908.

McCrae's greater fame came from his heart-rending poem, *In Flanders Fields,* which is reproduced and quoted to this day in armistice observances throughout the English-speaking world.

Despite the pressures resulting from war work and a heavy load of lectures both at Oxford and throughout the United Kingdom, Osler managed to maintain a vigorous correspondence with his friends at McGill, Johns Hopkins, Yale and Philadelphia and to contribute letters to the editors of major

health affairs; his outlook has always been of the broadest nature; his instinct for first causes as opposed to end results has been singularly sure.... No man is so capable as Sir William Osler of drawing together British and American medicine.

During this year, the final one of his life, honours continued to be heaped upon him. In March he was elected to membership in "The Club," sometimes known as "Dr. Johnson's Club." It was the most famous of the world's dining clubs and included among its members such dignitaries as Rudyard Kipling and John Buchan, the Canadian Governor General and writer. In its many years of existence, it had accepted only six doctor-members. Slightly later, Osler became president of the Ashmolean Natural History Society of Oxfordshire. He was never to present the presidential address he had prepared for delivery in January 1920.

On the 15th of July, having celebrated his seventieth birthday, "my Pneumococcus struck in," Osler wrote. "I had a high fever and have been in bed ever since." His illness continued, and although he maintained an active correspondence from his sickbed, he never fully regained his health. He was well enough to go with Lady Osler to the island of Jersey for six weeks later in the summer, and while there he began to regain his appetite and spirits. His improvement proved temporary, and he suffered a relapse after he and Lady Osler returned to England. On December 29, 1919, he had a severe hemorrhage and, in the words of Cushing, his biographer, died "quietly and without pain."

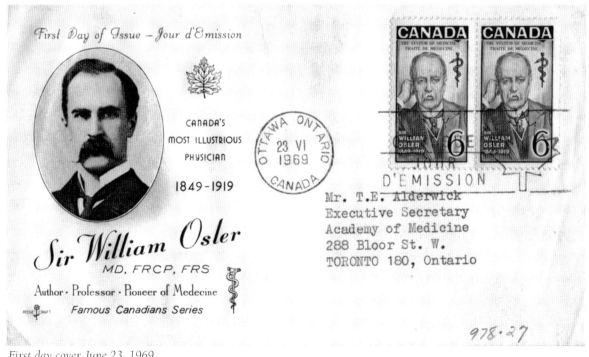

First day cover, June 23, 1969.

Conclusion

IT IS NOT possible in this brief account even to list all of William Osler's contributions to the world of medical education and practice. Instead, I have dwelled on some of those accomplishments that have a lasting influence on us.

An idea of Osler's powerful influence on others can be gained from first-hand accounts of some who came into contact with him. One of Osler's most outstanding protégées – Dr. Maude Abbott of McGill – became a world leader in her studies of congenital heart disease. Abbott had just turned 30 when she first met Osler, 20 years her senior, during a visit to Johns Hopkins in 1899. She wrote:

> I had the privilege of making rounds with him and a group of his students and physicians. Not only this, but he invited me to dinner at his house, and afterwards I was present at one of his famous student evenings, at which nine young men and two young women, his case reporters at the Hospital, sat around a large dining table, and I beside him at one end.
>
> After showing us all some rare first editions from early masters of medicine, and then discussing with them the problems and points of interest in their cases for the week, he turned suddenly upon me, as I sat there with my heart beating at the wonderful new world that had opened so unexpectedly before me, with the words: "I wonder now if you realize what a splendid opportunity you have in that McGill Museum. When you go home look up the article by Sir Jonathan Hutchinson on his 'Clinical Museum' in the *British Medical Journal* for 1893. Pictures of life and death together – wonderful, and then see what you can do.

The impact of this brief encounter was so powerful that it changed Abbott's life forever, diverting her into a career as museum curator and later, at Osler's urging, into studies of congenital heart disease. She would catapult into world prominence as one of the outstanding medical academics of her time. Such reactions to the potent Osler personality were common throughout his career, and Abbott was but one of many who came under his powerful influence.

Probably Osler's most important educational innovation was his reintroduction of clinical clerkship, which had been briefly tried and then abandoned prior to the U.S. Civil War. In the clerkship program, students in their final year of medical school were assigned responsibility for recording the histories and physical findings of ward patients and for reporting on their cases to their teachers. This approach to learning by doing supplemented and to some extent replaced the didactic teaching by classroom lectures of textbook study. The method was picked up by other schools in the United States and Canada where it has been standard practice ever since.

During his time at Johns Hopkins, Osler was the first in North America to use the clinical laboratory

as an aid to diagnosis. As K.M. Ludmerer explained, in *Learning to Heal,* "he exemplified the modern medical scholar who had arisen from an earlier era of great clinicians." Although Osler never made any contributions to experimental medicine, he excelled as a teacher and diagnostician. His influence in these capacities continues to permeate the medical education programs at McGill, Pennsylvania and Johns Hopkins in North America, and Oxford in the United Kingdom.

Perhaps the greatest legacy of Sir William was his interest in bibliophilia. Already apparent when Maude Abbott visited him at Johns Hopkins, Osler's passion for books was fully realized during his Oxford years. It was his avid interest in great literature from all eras that made him a man for all seasons. His erudition, and his capacity to display it without ostentation, gave him entry to the academic world of the arts as well as the sciences, an accomplishment as rare then as it is today and one from which he gained influence and respect far beyond the restricted world of medicine.

From Osler, students and colleagues learned to be more humane and less coldly scientific in their approach to their patients. His essays and addresses clearly exemplify this aspect of his personality and deal as much with the ethics and philosophy of living as with the science of medicine. Undoubtedly, the great breadth of Osler's reading had a profound influence on him. Osler bequeathed his magnificent library to McGill, along with an endowment to maintain it and the chair for the history of medicine. It seems fitting that the first occupant of that chair was Osler's nephew, the late Dr. William W. Francis. The library is certainly his most poignant legacy, and it is this extensive collection of literature that best illustrates the industrious and exceptionally imaginative man that was Sir William Osler.

Notes

Much of the material in this section is derived from Cushing or Ludmerer.
Quotations not otherwise attributed are from Cushing.

1. K.M. Ludmerer, *Learning to Heal: The Development of American Medical Education* (New York: Basic Books, 1985), p. 3.

2. Harvey Cushing, *Life of Sir William Osler,* 2 vols. (Oxford: Clarendon Press, 1925). 3. Cushing, Life, vol. 1, p. 74.

4. William Osler, *Aequanimitas and Other Addresses* (Philadelphia: P. Blakiston's Son and Co., 1925), pp. 413–443.

5. William Osler, *Canadian Medical and Surgical Journal* (1873–74), p. 308.

6. Cushing, *Life,* vol. 1, p. 123.

7. In February 1876 Osler gave the Somerville Lecture, "Animal Parasites and Their Relation to Public Health," before the Natural Historical Society.

8. Cushing, *Life,* vol. 2, p. 274.

9. Cushing, *Life,* vol. 1, p. 154.

10. Ibid, p. 234.

11. William Osler, *The Haematozoa of Malaria* (Philadelphia: Transactions, Pathological Society of Philadelphia, 1887).

12. Ludmerer, *Learning,* p. 58.

13. Cushing, *Life,* vol. 1, p. 341.

14. Ludmerer, *Learning,* p. 58.

15. Cushing, *Life,* vol. 2, p. 36.

16. My great-aunt Elsie Sutherland, a nurse who was in Britain during Osler's time at Oxford, told me that Osler's fees were a "guinee a mile"; that is, about five dollars. Since his practice encompassed much of the United Kingdom, it must have generated a very large income.

THE OSLER LEGACY

Essays by:

Lawrence D. Longo, M.D. Faith Wallis, Ph.D. Lord Walton of Detchant

A Commitment to Excellence

I T IS commonly said that William Osler was the greatest physician of the past century. As a clinician-consultant, teacher, medical educator, historian, classicist and biographer, he greatly influenced succeeding generations, and the effects of his medical philosophy are still visible today. A scholar and a bibliophile, he wrote more than 1,500 articles and books and amassed one of the largest and finest contemporary collections of rare medical works. Yet despite his many contributions and a virtual flood of articles and books about him, relatively few people outside of the field of medicine know of Sir William Osler. Today many medical students and house staff are only vaguely aware of his life and the immensity of his work.

Osler was committed to excellence in all that he did and wrote. He was influential primarily because of his scholarship. The decade Osler spent in Montreal performing over a thousand autopsies and studying in the laboratory laid the foundation for his development into a highly regarded consultant in internal medicine. He recognized that it was very important "to make the lesson of each case tell on your education" (*The Army Surgeon*). His commitment to the idea that clinical experience and the study of medicine are inextricably related is clearly put forward in *Books and Men*. "To study the phenomena of disease without books is to sail in uncharted seas, while to study books without patients is not to go to sea at all," he wrote.

Both students and practitioners held Osler's *The Principles and Practice of Medicine* in high esteem. They appreciated his clear writing style and recognized his ability to synthesize facts. A collector of information, Osler often recorded his ideas on slips of paper and was gifted in putting ideas and data together to make an understandable whole. This, in addition to the fact that Osler's expert skills were derived from extensive experience, that he had a broad knowledge of literature including French and German writings and that he had a remarkable memory, gave him a well-deserved reputation.

In his biographical and other historical studies, Osler demonstrated the same level of accuracy, attention to detail and ability to discover a fresh point of view. Helping to preserve the great works of the past and develop historical collections, he emphasized the necessity of reading the work of these writers and understanding their writing within the context of their times. In *Books and Men* he said, "It is astonishing with how little reading a doctor can practice medicine, but it is not astonishing how badly he may do it."

Osler's extensive knowledge of the Holy Scriptures and the classics of literature is also evident throughout his work. Four great healers – Thomas Linacre, scholar, physician and humanist; William Harvey, physician-scientist who discovered the circulation of the blood; Sir Thomas Browne, writer and physician-humanist; and Thomas Sydenham, the "English Hippocrates" – inspired Osler to follow their paths.

Over the years, Osler developed three personal ideals: to do the day's work well and let the morrow take care of itself; to exercise the golden rule toward professional brethren and patients; and to cultivate equanimity. In essays such as *Aequanimitas* (1904), *The Student Life* (1905), *Unity, Peace and Concord* (1905) and *A Way of Life* (1913), he eloquently expresses the ideals of what it means to be a healer – ideals that continue to be a great inspiration to others.

During his 16 years at Johns Hopkins especially, Osler attracted the brightest and the best students and house staff to his circle. Rather than maintaining the typical European Geheimrat relationship to those who worked under him, Osler was a friend and fellow student to all. In the ambience of William and Grace Osler's homes in Baltimore and Oxford, these individuals caught a vision of the possibilities of medicine and were inspired to contribute to life. Undoubtedly, the mark of a great educator and academician is the work and influence of his followers. People who trained with William Osler invariably went on to become leaders in Canada and the United States in academic medicine and internal medicine, as well as other specialties.

John D. Rockefeller was so impressed by *Principles and Practice* that he founded the Rockefeller Institute in 1901. He also funded full-time clinical chairs at Johns Hopkins and several other universities and extended his philanthropy to endow the Johns Hopkins School of Hygiene and the Institute of the History of Medicine.

In part in an effort to perpetuate the examples, ideals and counsels of William Osler, a group of former students and others met to form the American Osler Society in 1970. This group sought to bring together members of the medical and allied professions who were, by their common inspiration, dedicated to memorialize and perpetuate Osler's just and charitable life, intellectual resourcefulness and ethical example. Representatives from the United States, Canada, Great Britain and Japan hold annual meetings, support historical research by medical students and publish proceedings. Their aim is to encourage succeeding generations to focus on ever-broadening horizons and to ensure that they do not sail as Sir Thomas Browne's Ark – without oars and without rudder and sails and, therefore, without direction.

Sir William Osler was a superb clinician-diagnostician, teacher, educator, writer, historian, biographer, bibliophile and philosopher. A Canadian by birth, he was never confined by his nationality and held professorships at major universities in Canada, the United States and Great Britain. His life and work continue to inspire and influence those in the medical profession, as well as the general public. Although the term "Renaissance Man" is overused and often too readily bestowed, certainly it applies to Osler, this nineteenth century educator whose message is timeless.

Much more than the sum of parts, Osler's scholarship, idealism and academic heritage provide a rich legacy and a source of inspiration for all. The challenge for us today is to learn from Osler and allow his philosophy and his example to guide us on the path that lies ahead.

Lawrence D. Longo, M.D.
Secretary-Treasurer, American Osler Society
Professor, Physiology and Obstetrics and Gynecology
Loma Linda School of Medicine, Loma Linda, California

The Man in the Library

THE PRESENCE of William Osler is evident the moment one walks through the doors of the Osler Library. From the main reading room, the Wellcome Camera, the eye is drawn through the marble archway into the lush elegance of the Osler Room with its oak panelling and Oriental carpets. In a niche at the end of the room, behind the bronze portrait plaque, lie the ashes of Sir William Osler himself. To keep Sir William company in his repose, we have arranged his own works in the cabinet to the visitor's left – the various editions of his great textbook, *The Principles and Practice of Medicine,* his five stout volumes of collected reprints, his monographs, essays, published and unpublished manuscripts and even his tiny pocket notebooks. In the cabinets to the right of the plaque are his favourite books, especially Sir Thomas Browne's *Religio Medici* and the works of François Rabelais and Robert Burton. In glass-fronted cabinets on either side, and over his head in our special rare books room, are the 8,000 volumes he bequeathed to his alma mater, McGill University in Montreal, the nucleus of the Osler Library of the History of Medicine.

Finding and acquiring these ancient works of medicine, and arranging and describing them in the monumental printed catalogue *Bibliotheca Osleriana,* was the central avocation of Osler's life and the principal solace of his last years. Yet the library was no mere genteel hobby, adorning a practical and scientific career with a patina of literary and bibliophilic culture. Osler's library of medical history was a carefully constructed message about the man's deepest values, a message written in code, or rather, in codices.

Sometimes notes penned by Osler are found inside the books themselves, like messages in bottles from shipwrecked sailors. Osler's habit of "filing" his correspondence in this way has served to hide away

Osler's desk; Osler Library, Montreal, Quebec.

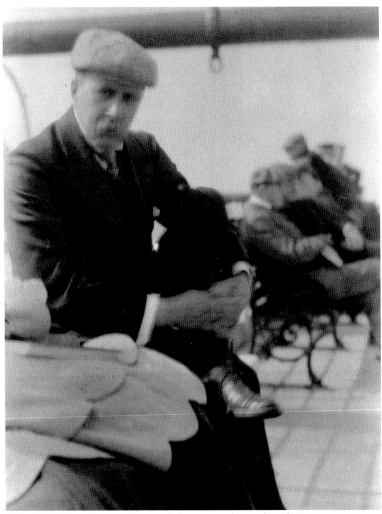

Behind Osler's serious professional demeanour lay a cleverly improper sense of humour; Osler on the steamer Celtic, 1905.

many intriguing scraps of his personal and professional life. Between the covers of his copies of William James's *Pragmatism* and Edith Wharton's *The Fruit of the Tree,* for example, lie letters which tell the whole inner story of Henry James's mental breakdown. Associations sparked by books also prompted Osler to use their flyleaves to record autobiographical reminiscences, like the account of his unique meeting with Darwin inscribed in his copy of *On the Tendencies of Species to Form Varieties.*

Bibliotheca Osleriana is arranged in a rather unusual manner devised by Sir William himself. It is divided into eight sections, of which the first two are prescriptive and the rest descriptive. The first part, *Bibliotheca Prima,* is a medical hall of fame. Osler thought of it as a syllabus for a course in the history of medicine, and so he arranged it chronologically, beginning with classical antiquity and proceeding down the ages to his own day. It is a sort of genealogy of the physician, a portrait-gallery of the ancestors. By studying medical history from the *Bibliotheca Prima,* students would acquire a sense of medicine as a dynasty or lineage of giants on whose shoulders they might climb to scan the horizons of the future. Beginning with Hippocrates, spanning the Latin and Arabic writers of the Middle Ages, the Renaissance discoveries in anatomy, physiology and pathology, the therapeutic revolution of Jenner's era and the birth of modern clinical medicine in the Paris of Laennec, he brings the story down to his own day with Koch, Pasteur and Röntgen.

Fortunately, Osler did not stop collecting with the great and famous. He added a *Bibliotheca Secunda,* an alphabetically organized "second library" of important or interesting but not, in his view, stellar medical works. The remainder of the catalogue is taken up largely by form-divisions – *Bibliotheca Historica, Bibliotheca Biographica* and so forth. However, his three favourite writers, Rabelais, Burton and Thomas Browne, are found in none of these. They are all denizens of the *Bibliotheca Litteraria,* the third division of the library. The mandate of the *Litteraria,* to quote a facetious remark by W.W. Francis, the first Osler Librarian, was to house literary works by and about physicians, or bad poetry by good doctors and good

poetry by bad doctors. In fact, the *Litteraria* is the most intriguing and surprising section of the whole library. It is, so to speak, Sir William's mental attic, where he tucked away all manner of oddities which did not seem to fit anywhere else. As a result, the *Litteraria* is exceptionally rich in clues about Osler's less official and more eccentric interests.

The code, then, is a complex one, addressing the public concerns of the medical profession and also revealing the private dreams – and even nightmares – of Osler himself. Like the two sides of a coin, the public Osler and the private Osler together convey a diverse but ultimately coherent and highly personal message about medicine.

Osler's commitment to integrating medical history into the training of medical students was acted out in many ways. He wove historical background into his textbook; he likewise exercised his students in the use of libraries to discover not only contemporary knowledge of disease but also something about its historical dimensions. His favourite students at Johns Hopkins, the fortunate latchkeyers, were granted access to his house and, above all, exposure to his library. Dinner parties for students and young colleagues ended with the dining room table covered in rare and valuable volumes, while the host talked about the men who wrote them, the age they lived in and the ideas they conveyed.

Osler did this out of conviction that medicine is a science first. Therefore, it grows by accumulation, each generation adding to the common store of experience and reflection that advances knowledge. Secondly, he believed that medicine is an art, an art practised on behalf of human beings. The physician must, then,

cultivate a deep sensitivity to those values that make our life truly human, as embodied in what Osler would have called "the humanities." Underpinning both is the virtue of humility; humble before the efforts and achievements of the past, humble in the face of the mysteries of the human soul, the physician should do his honest day's work to add his own brick to the edifice of knowledge and to care for the suffering in all their many-sided frailty and pain.

This is an old-fashioned message but one whose nobility still radiates a claim to timeless truth. It is all the more convincing when one looks closely at those three favourite writers who keep Sir William Osler company in his niche: Rabelais, Burton, Thomas Browne.

François Rabelais, author of the flamboyant, bibulous, scatological satires *Gargantua* and *Pantagruel*, earned his bread as a physician to the Bishop of Paris. His favourite medicine, however, was laughter, and Osler's note in the *Bibliotheca* about the first dated collected edition of Rabelais' works reveals something of why he admired this writer:

> For the sick, the gouty and the unfortunate in their sore discomfort Rabelais had composed the Books, as he could not possibly take under his personal care all who needed his service. Contemplating the qualities of his physician, whether sour, morose and depressed, or serene, pleasant and smiling, so the patient is influenced by a transfusion of the spirits; and the author in making public these joyous Books gives joyous pastime to many sick and languishing of whom he cannot possibly take charge. The careful physician has but one end in view – not to depress his patient in any way whatever.

Now the idea that it was a part of the physician's ethical duty to cultivate a calm cheerfulness, an aequanimitas, was not only Osler's official precept to his students and colleagues but his own careful practice as well. "Aequanimitas" was the motto he chose for his coat-of-arms when he was knighted in 1911, and there are countless anecdotes, some of them extremely touching, about how his bedside manner served to allay the distress of some suffering patient. Even away from the bedside, he was known for his sunny good humour and his somewhat sophomoric practical jokes. But I think Osler's affiliation with Rabelais goes rather deeper than a simple sense of fun and love of a good laugh, deeper even than the quest for a therapeutic aequanimitas.

Osler had a very Rabelaisian alter ego, a gentleman named Egerton Yorrick Davis, M.D., U.S. Army (retired). Behind the mask of E.Y. Davis, Osler played Rabelais by indulging a most un-Victorian penchant for scurrilous humour of a scatological and sexual nature. Using this nom-de-plume, he penned a number of articles on some rather unusual medical cases. So cleverly did these essays skirt the edges of parody that most of the journal editors to whom they were sent for consideration rose to the bait without a twitch of suspicion.

Davis's career is well known, but I would like to underscore the quintessentially satirical side of his oeuvre. The aim of E.Y. Davis's productions was frankly to bamboozle especially humourless editors of particularly prestigious medical journals, to catch the pretentious bigwigs with their trousers down and make fools of them. Weary perhaps of his own literary efforts, Egerton Yorrick Davis took to collecting books for the Osler Library. Many works of very Rabelaisian taste can be found in the *Bibliotheca Litteraria,* and not a few are devoted to pricking the historic self-importance of the medical profession. He liked to collect books by and about famous quacks, for quackery is a commentary not only on the gullibility of the public but also on the pretentiousness of the physicians; a quack merely exaggerates the claims of mainstream medicine. In short, laughter is not only good medicine for the patient but a salutary tonic of humility for the profession.

The second of the favoured authors who rest at Osler's side in the Osler Library is Robert Burton, author of *The Anatomy of Melancholy.* Burton was a seventeenth century divine and Oxford scholar who applied his enormous and miscellaneous reading to a most unusual therapeutic project. Being a melancholic himself and finding no cure in physic for his condition, he proposed to write his way out of it by writing about it. Osler called *The Anatomy* the greatest medical work ever written by a layman. In its pages, Burton analyzes folly, obsession and despair in all their complexions: jealousy, love-melancholy, religious melancholy and the desk diseases of scholars. His quirky agglutinative prose is seamed with fascinating digressions on dreams, on genius and madness, on depression and suicide. It seems an odd book to be the particular favourite of a man who preached æquanimitas and who was loved for his cheerful demeanour. Did Osler read and reread this odd and digressive encyclopedia of depression merely to vaccinate himself against the malady?

Here we have inadvertently broken into the great secret of Osler's personality: his public precept was

often the polar opposite of his private reality. Indeed, what he preached in public was often a deliberate antidote to an inner, emotional reality that was painful and perhaps dangerous for him. Osler's motto was indeed æquanimitas, but he died of a broken heart; in his famous essay "A Way of Life," he advised forgetting the past, but his oldest memory, recorded in a discarded draft of the same essay, is both vivid and stark: the death of his infant sister. If Osler harboured a secret Rabelais in his bosom, he also nurtured an inner Burton, and if he had no inclination to imitate Burton in writing a book about his melancholy, he could at least buy books about melancholy.

Madness, folly, depression occupy an unexpectedly prominent place on the shelves of Osler's Library, though curiously he was not very interested in the modern psychiatric approach to these problems. Osler referred patients to Freud on occasion but never bought his books. There is, however, a single exception – *The Interpretation of Dreams*. Osler was particularly attracted to his book because he was interested in the interpretation of his own dreams, especially the dreams he had at certain critical and stressful times of his life. Those recorded following the death of his son Revere, for instance, are profoundly eerie, as is the dream in which Osler attended his own post-mortem. One wonders why he was so solicitous to remember dreams, especially sad dreams, this man who preached the value of forgetfulness and the dangers of morbid introspection. The plain fact is that Osler was a much more complex and ambivalent personality than his glowing icons would suggest.

Favoured among the authors in Osler's library is Robert Burton, an Oxford scholar and a professed melancholic.

Another of Osler's precepts was that a wise physician will strictly separate science and religion, placing them in hermetically sealed compartments in his mind lest they contaminate one another to their mutual harm. He lived, after all, in an age when science and religion were frequently embroiled in unedifying and futile disputes. His own rather difficult

decision to abandon his father's clerical profession in favour of medicine was very probably triggered by Darwinism. He never wanted to talk about that decision, which obviously had cost him much, but one suspects that he never really worked it out fully. Indeed, he loaded the shelves of his library with dozens of books which more or less openly defy his statute of segregation. For a man who professed to separate science and religion, it is rather curious that Osler's favourite book of all bore the title of *Religio Medici,* "the physician's religion."

The author of this work was Thomas Browne, physician of Norwich and one of the finest writers of English prose of the seventeenth century. For Osler, Browne was his ideal self, a man of gentle, uncomplicated æquanimitas, deep charity and tolerance and selfless scientific curiosity. He collected every edition of every work of Browne's he could acquire, including some unusual manuscripts and archival materials and some exceedingly rare items like the sale catalogue of Browne's library. The *Religio* was by far the most important of these.

As a young man, Osler officially changed his vocation from religion to science, and later he publicly recommended their strict divorce. But his deep affection for Browne's *Religio Medici* only thinly veils his regret at this forceable separation and his nostalgic admiration for men who could unite the two professions. It was, after all, just such a man, the clergyman-naturalist W.A. Johnson, who introduced Osler to this book. Double vocations, especially those spanning religion and science or medicine, held a special fascination for Osler. Not only Johnson but also Osler's revered second mentor, James Bovell, combined holy orders and a life of science. A rather shadowy but very significant figure in Osler's imaginary universe, his uncle Edward was a physician who wrote both treatises on marine biology and disquisitions on High Churchmanship. Officially, medicine and faith were incompatible; unofficially, Osler could never disentangle them.

A whole volume could easily be written on the priesthood of Sir William Osler. He unabashedly referred to his inspirational addresses to his colleagues and students as "lay sermons," but more than that, he laced them so liberally with quotations from the Bible and the Book of Common Prayer that they could almost pass for pulpit literature. Allusions to the profession as a brotherhood, or even as a priesthood, are far from uncommon, and Osler once compared his peregrinations through Maryland to rouse interest in local medical societies to the "circuit riding" of old-time Methodist travelling preachers. He wrote hagiographical memoirs of his unsung heroes, men like John Bassett, the "Alabama Student," in which he plainly calls them mystics and martyrs. These are, I think, more than handy analogies drawn from his horde of early experiences. Though in the early days a devout High Church Anglican, Osler became later in life a somewhat irregular churchgoer, and in Oxford he actually scheduled his rounds in the Radcliffe Infirmary for Sunday mornings. It would seem that as he slowly fused together his clerical and his medical vocations, it was medicine which won.

But the books Osler collected tell a more complex story of scientists martyred by the forces of organized religion, like Michael Servetus, but also of

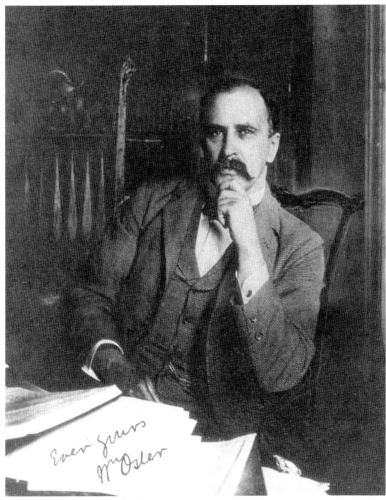

Osler was neither a medical superman nor a Victorian plaster saint. Clues to his complex personality can be found in the books he collected.

Thus there are two books from which I collect my divinity: besides that one written of God, another of his servant nature, that universal and public manuscript, that lies expansed unto the eyes of all; those that never saw him in the one, have discovered him in the other.

Osler's contemporaries admired the public values, but perhaps the message which is most relevant to the modern student and practitioner is one that comes from Osler's private side rather than his public persona. It would be well to remember that Osler's splendid life and achievements unfolded against a secret backdrop of inner contradictions, unfinished business, conflicts and wounds. His energy, productivity and humanity blossomed out of a deep vulnerability. Few of his contemporaries knew this, but he left clues and traces of it in his library. Between the pages of his books we can still encounter an Osler who is neither a medical superman nor a Victorian plaster saint but rather a perennial model and source of authentic inspiration to the modern physician, who each day confronts, as he did, the tension between the scientific challenges from without and the human values that spring from within.

medical men devoting themselves to the cause of Christianity and humanity, like Livingston. The passage from *Religio Medici,* chosen by Cushing to be the epigraph of his biography of Osler, well conveys Osler's complex and ambivalent attitude toward religion and medicine, at once a harmonization of the two and an effort to delimit and distinguish them. Medicine is superior to theology because it is universally accessible, but at the same time it is the handmaid of theology because its ultimate goal is the knowledge and love of God.

Faith Wallis, Ph.D.
Osler Librarian, McGill University
Montreal, Quebec

Open Arms

WHEN I MOVED to Oxford in 1983 to become warden of Green College, I was very excited to learn that I would have responsibility for 13 Norham Gardens. From 1907 to 1919 this house had been the residence of the regius professor of medicine at Oxford, Sir William Osler, and his wife, Grace. Because of the outstanding hospitality and welcome the Oslers extended to doctors, medical students and others visiting Oxford, their home was nicknamed the "Open Arms."

I became fascinated by the great Sir William Osler when I was a medical student at the University of Durham in Newcastle upon Tyne. Not only was Osler a compelling individual, but his writings were outstanding in the field of modern medicine. Indeed, the first paper I ever wrote as a student was about him.

Many years later, when I was president of the British Medical Association and the association was in its 150th year, I was invited by the editor of the *British Medical Journal* to write an article for the anniversary issue. I was told the subject was to be the medical book I would most like to have written. I chose Harvey Cushing's *The Life of Sir William Osler*, and without collusion two of the other chief officers chose Osler's *Aequanimatas*. I was also greatly honoured to be invited to give the Osler Oration at the annual meeting of the Canadian Medical Association in Halifax many years ago and later to be elected an honourary member of the American Osler Society. My interest in Sir William Osler has not diminished.

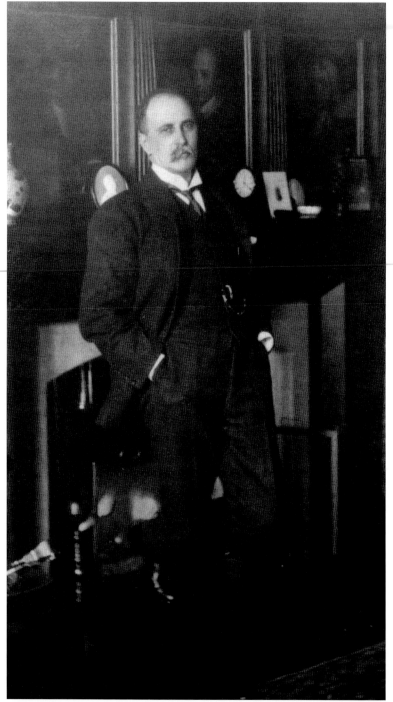

Osler in the library of the "Open Arms"; Oxford, 1907.

In her will, Lady Osler left the "Open Arms" to Christ Church College of the University of Oxford, to be used as a home for the regius professors of medicine. Except for two professors, subsequent holders of the office chose to live elsewhere. The university then leased the property for 21 years to Green College, and now the college is responsible for the maintenance of the property.

At present, the house contains four apartments for married students of the college, premises for the University Newcomers Club, an apartment for the regius professor and, on the ground floor, the Osler Library and an adjacent office which I rent.

When I became warden of Green College, I established an organization called the Friends of 13 Norham Gardens and embarked on a major fundraising campaign for the repair and refurbishment of the property. I am pleased to say that through the generosity of many individuals and organizations from all over the world, this campaign has been successful.

In Osler's former library, we have collated and catalogued a large number of books, papers and Osler memorabilia. We are also collecting for display to visitors items relating to Osler. It is my hope, under the auspices of the Friends, to continue with this policy; visitors will be welcome by appointment. We are also delighted to accept new members of the Friends; they will receive our annual newsletter with information about recent acquisitions and activities.

It is our intention to maintain Osler's former home and splendid library in the manner he would have wished. The "Open Arms" is a living tribute to a great man and an outstanding physician.

Lord Walton of Detchant
Chairman, Friends of 13 Norham Gardens
Former Warden, Green College, Oxford, England
Former Dean of Medicine,
University of Newcastle upon Tyne
President, World Federation of Neurology

A Photographic Tribute

by Ted Grant

Introduction

"It was like a scene from the movies: bright lights, active people, shining equipment. It cried out to be photographed. And what a great place to shoot!" This was the last recollection I had before being anesthetized. Dr. Brien Benoit, chief of neurosurgery at the Ottawa Civic Hospital, was about to operate on me for trigeminal neuralgia.

Some months following my surgery, I asked Dr. Benoit if I could spend a week photographing his activities as a neurosurgeon. The week initiated an assignment that has become one of the major works of my 50-year career as a photojournalist.

In the beginning, I never thought of this project as a book, but more as a record of the doctor I encountered during an emotional time in my life.

As one physician pointed out, "The book captures our feelings, concerns and dedication in a candid manner rarely seen in a collection of photographs. And combined with the quotations of Dr. Osler, it is a constant reminder of why I became a physician. It is my work." I'm very grateful to the doctors and nurses who permitted me to work with them. They contributed to the success of this project.

Some of the photographs may no longer depict the most recent equipment or the latest technique. But the message is the same as when the photos were taken: the picture illustrates dedicated human beings caring for those who have placed their trust in them.

I would like to acknowledge the passing of Dr. Douglas Waugh. His contribution of historical background about Sir William Osler became the catalyst for this collaboration between Osler's words and my photographs.

Ted Grant

I have three personal ideals. One, to do the day's work well and not to bother about tomorrow … the second ideal has been to act the golden rule, as far as in my lay, toward my professional brethren and toward the patients committed to my care. And third has been to cultivate such a measure of equanimity as would enable me to bear success with humility, the affection of my friends without pride, and to be ready when the day of sorrow and grief came to meet it with the courage befitting a man.

Sir William Osler

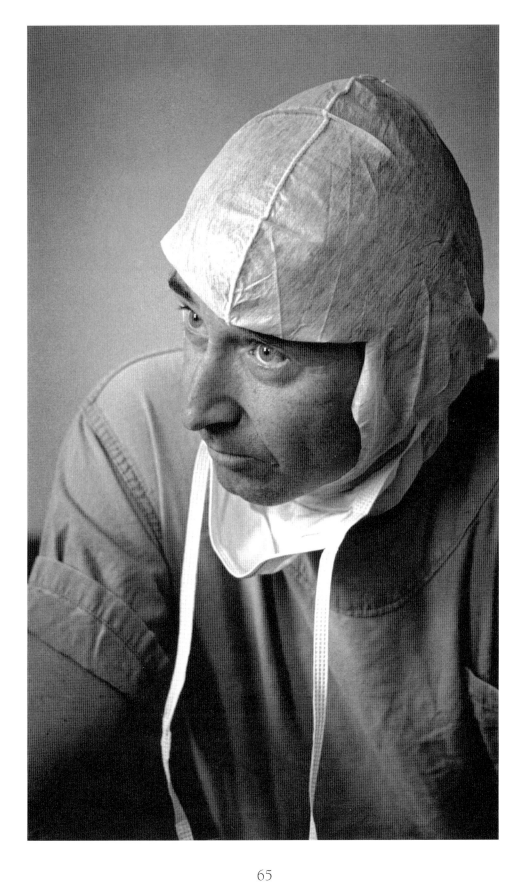

No special virtues are needed
[for nurses], but the circumstances
demand the exercises of them in
a special way. There are seven,
the mystic seven, your lamps to
lighten at.… Tact, tidiness,
taciturnity, sympathy, gentleness,
cheerfulness, all linked together
by charity.

Sir William Osler

*Modern medicine is a
product of the Greek
intellect and had its origin
when that wonderful
people created positive or
rational science.*

Sir William Osler

Do not waste the hours of daylight in listening to that which you may read by night.

Sir William Osler

*The successful teacher is
no longer on a height,
pumping knowledge
at high pressure into
passive receptacles …
[but rather] a senior
student anxious
to help juniors.*

Sir William Osler

The important thing
is to make the lesson
of each case tell
on your education.

Sir William Osler

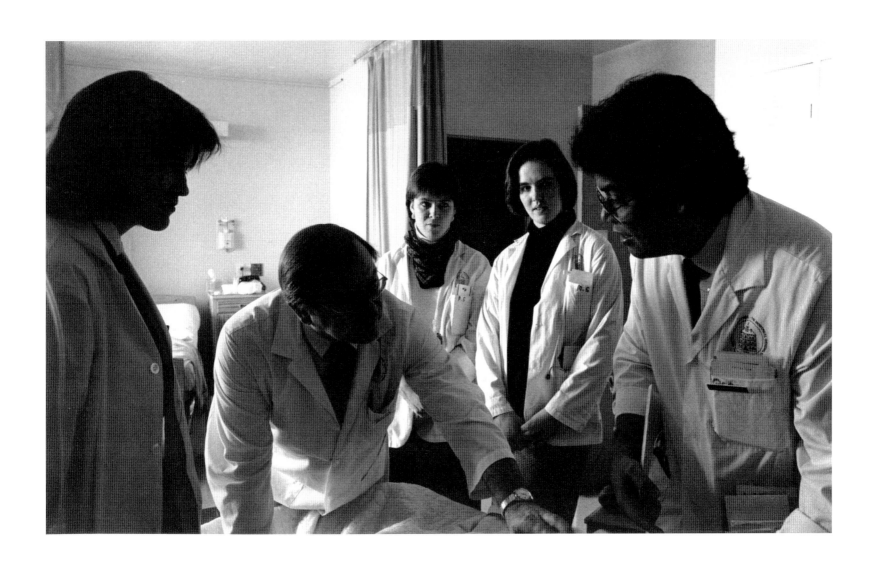

Learn to see,
learn to hear,
learn to smell.
Know that by practice
alone can you
become an expert.

Sir William Osler

*The hardest conviction
to get into the mind of the
beginner is that the
education upon which she
is engaged is not a college
course, not a medical
course, but a life course.*

Sir William Osler

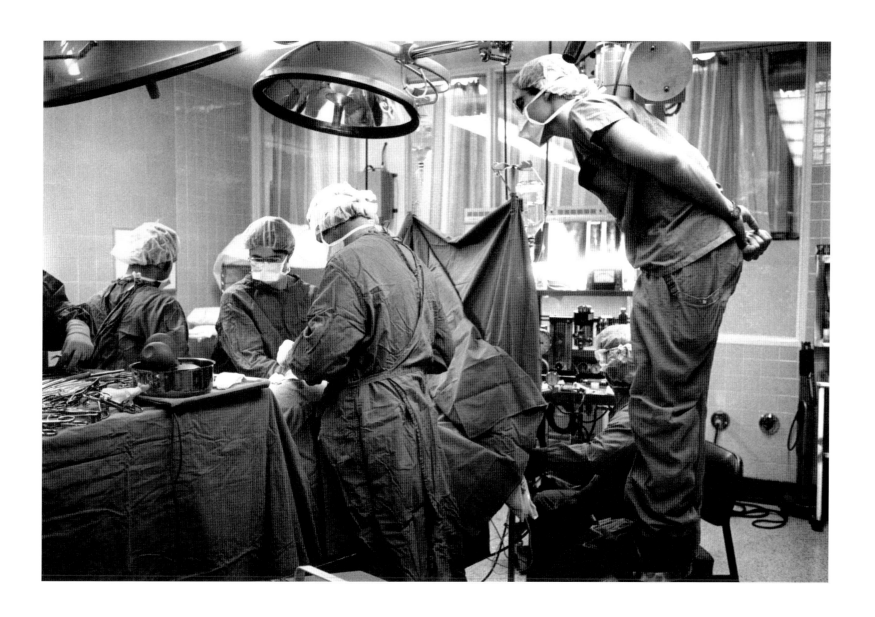

*It is by your own eyes and
your ears and your own
mind and (I may add)
your own heart that you
must observe and learn.*

Sir William Osler

Medicine is learned by the bedside and not in the classroom.

Sir William Osler

*Palpitation of the heart in
a medical student may be
the result of a lobster
salad the night before or
the girl he left behind.*

Sir William Osler

*Common sense nerve
fibres are seldom
medullated before forty
– they are seldom seen
even with a microscope
before twenty.*

Sir William Osler

The trained nurse has become one of the great blessings of humanity, taking a place beside the physician and the priest, and inferior to neither in her mission.

Sir William Osler

Education is a lifelong process in which the student can only make a beginning during … college.

Sir William Osler

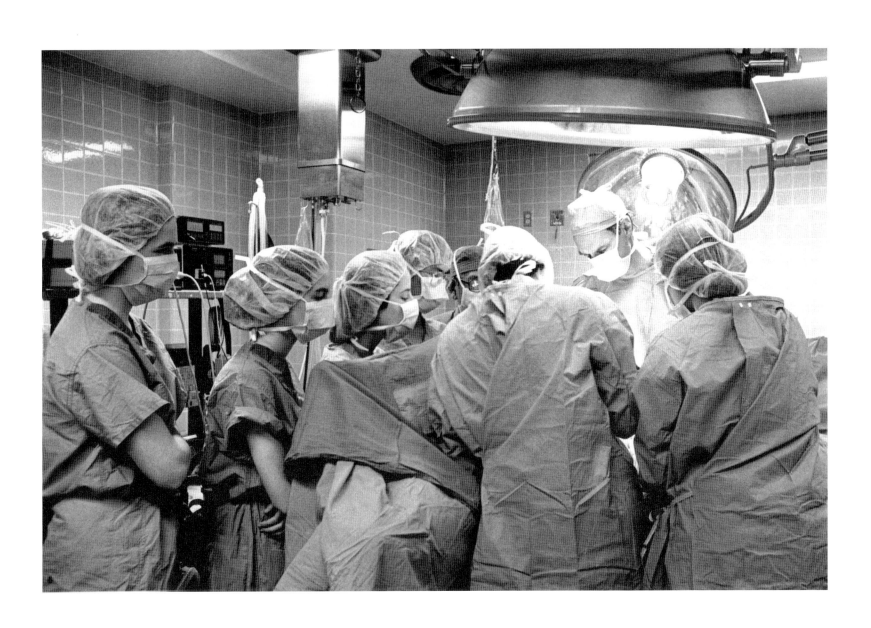

*Nothing contributes so
much to tranquillize the
mind as a steady purpose
– a point on which
the soul may fix its
intellectual eye.*

Mary Wollstonecraft Shelley

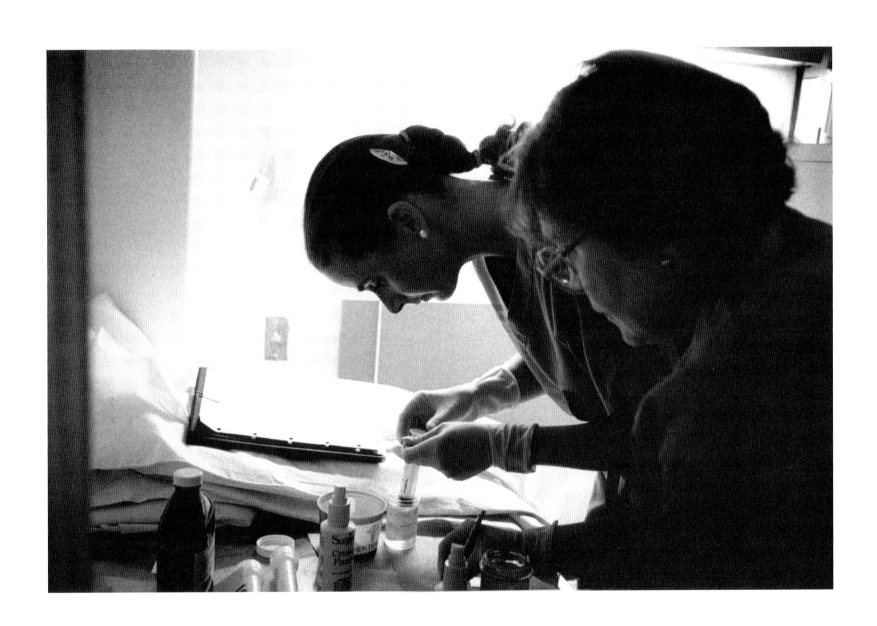

The value of experience
is not in seeing much
but in seeing wisely.

Sir William Osler

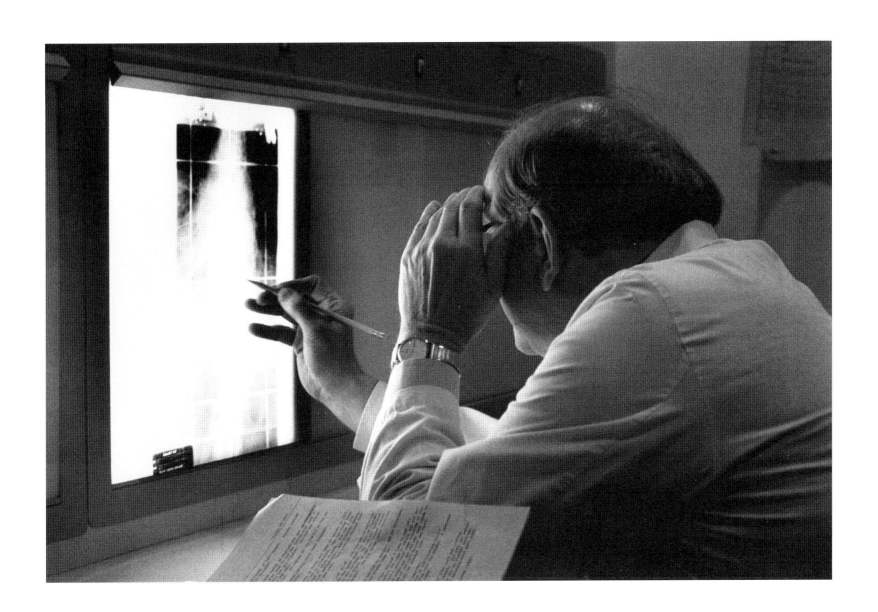

*Knowledge comes, but
wisdom lingers.*

Sir William Osler

*Our main business is not
to see what lies dimly at a
distance but to do what
lies clearly at hand.*

Thomas Carlyle

*There is only one
cardinal rule:
one must always
listen to the patient.*

Dr. Oliver Sacks

Things cannot always go your way. Learn to accept in silence the minor aggravations, cultivate the gift of taciturnity.

Sir William Osler

*Concern for man himself
and his fate must always
form the chief interest of
all technical endeavours …*

Albert Einstein

The best quarantine
is hygiene.

Richard D. Arnold

The book of Nature is that which the physician must read; and to do so he must walk over the leaves.

Paracelsus

*It may seem a strange
principle to enunciate as
the very first requirement
in a Hospital that it should
do the sick no harm.*

Florence Nightingale

Were there none who were discontented with what they have, the world would never reach anything better.

Florence Nightingale

*Modern science has made
to almost everyone of you
the present of a few years.*

Sir William Osler

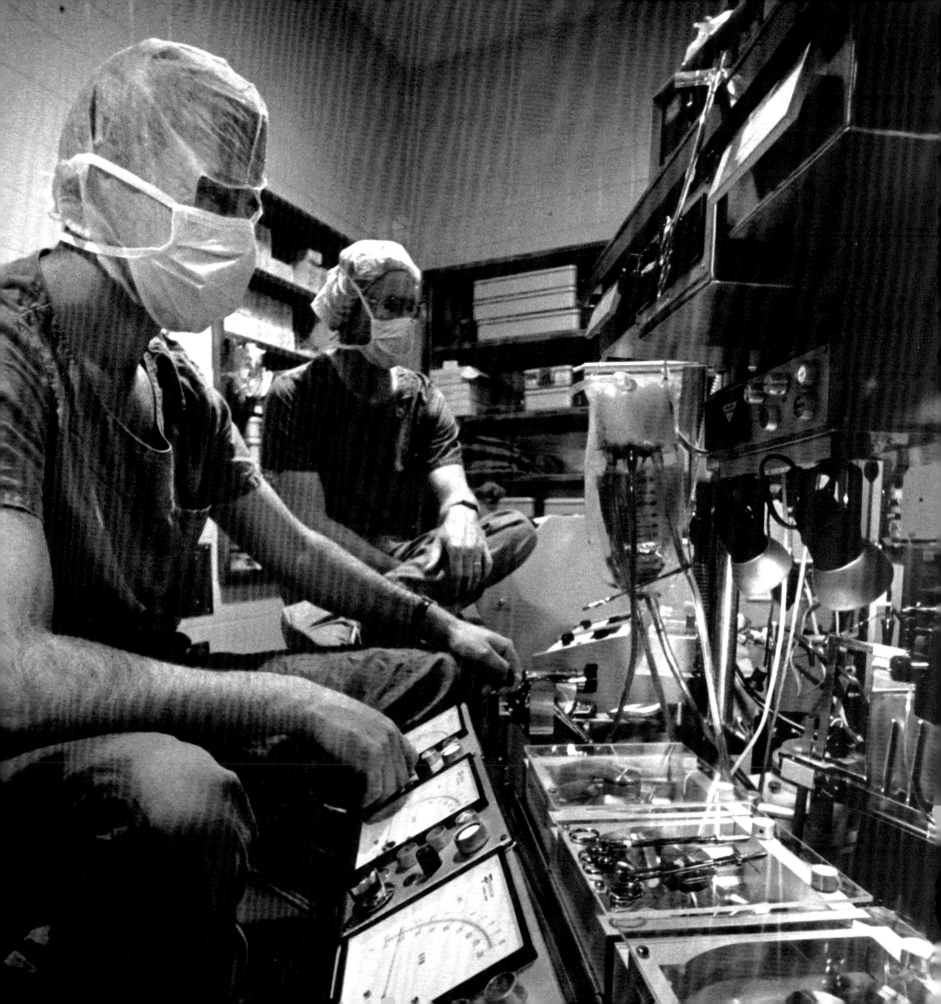

Anaesthesia …
the nemesis
which has overtaken
pain.

Sir William Osler

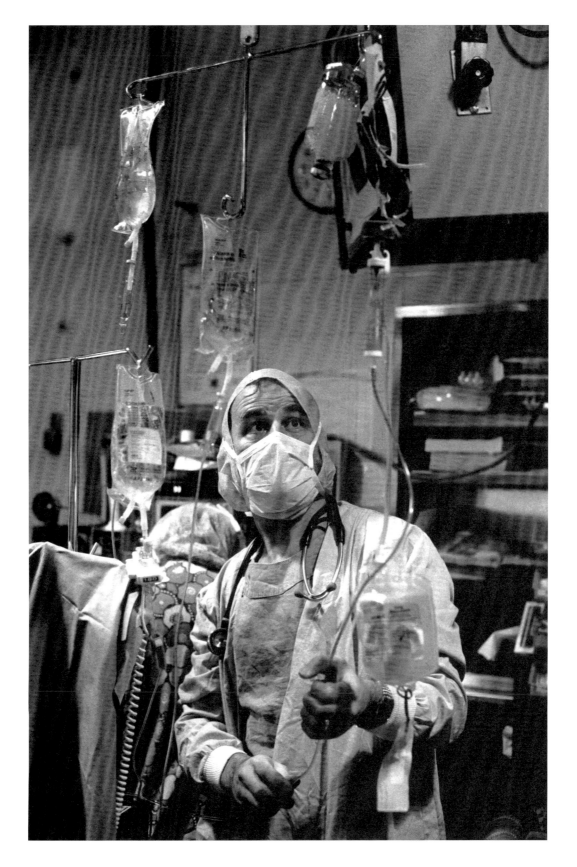

You must put your
emotions on ice.

Sir William Osler

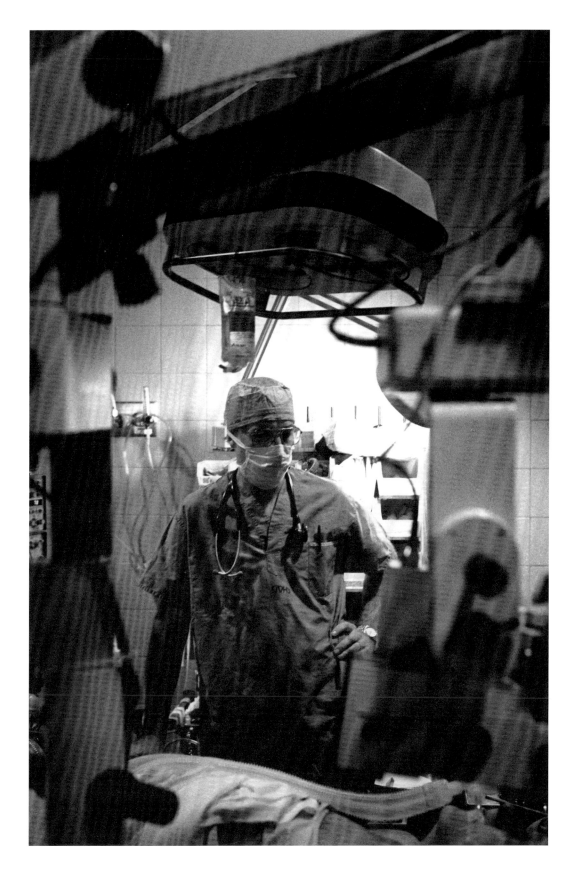

The heart is a tough organ: a marvellous mechanism that will give valiant service up to a hundred years.

Dr. Willis Potts

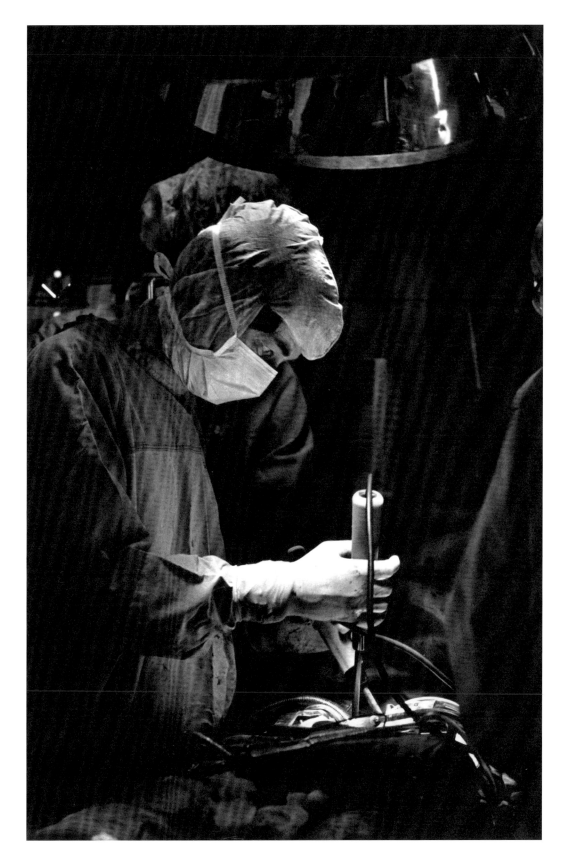

*A well-trained, sensible
doctor is one of the most
valuable assets of
a community.*

Sir William Osler

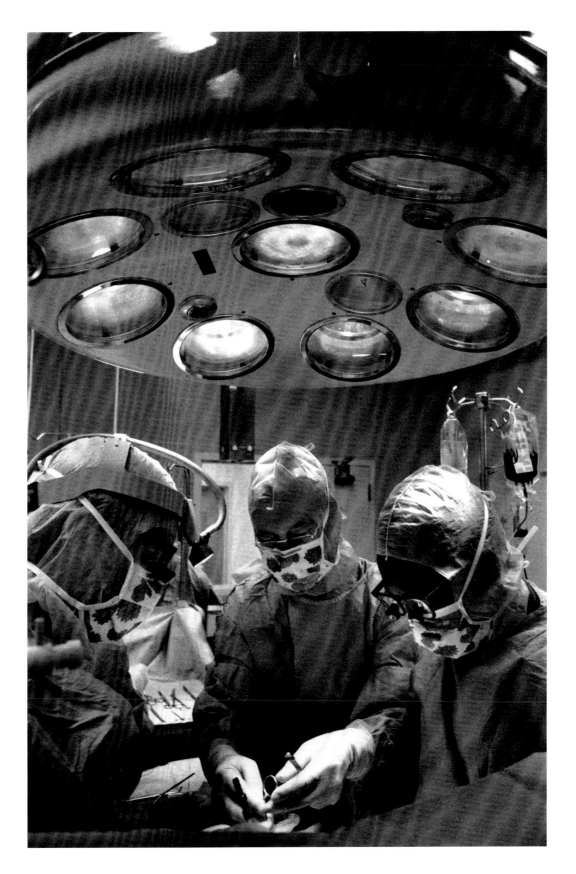

We are here to add what
we can to, not get what
we can from, life.

Sir William Osler

One never notices
what has been done;
one can only see
what remains
to be done.

Marie Curie

The greatest republic of medicine knows and has known no national boundaries.

Sir William Osler

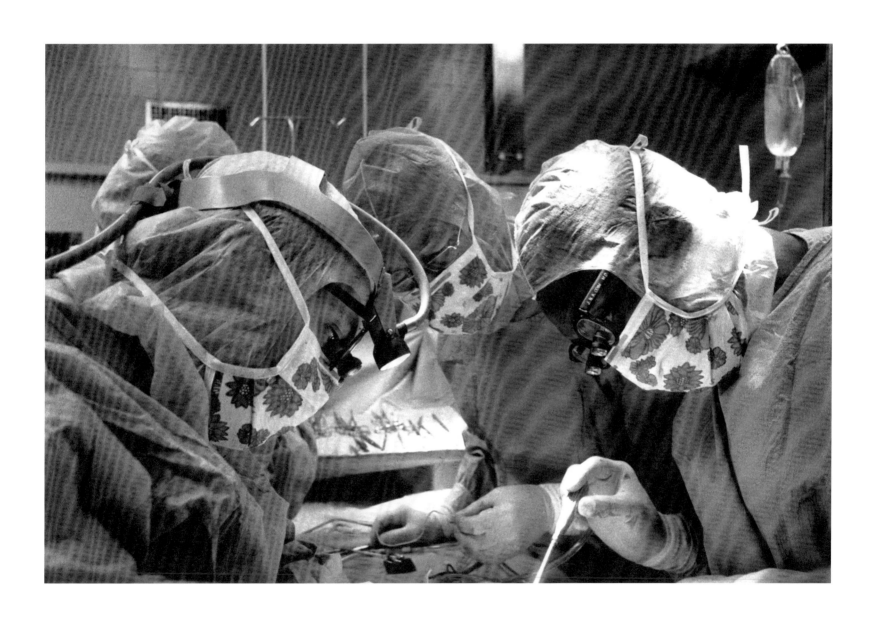

The practice of medicine
is an art, not a trade;
not a business,
a calling in which
your heart
will be exercised equally
with your head.

Sir William Osler

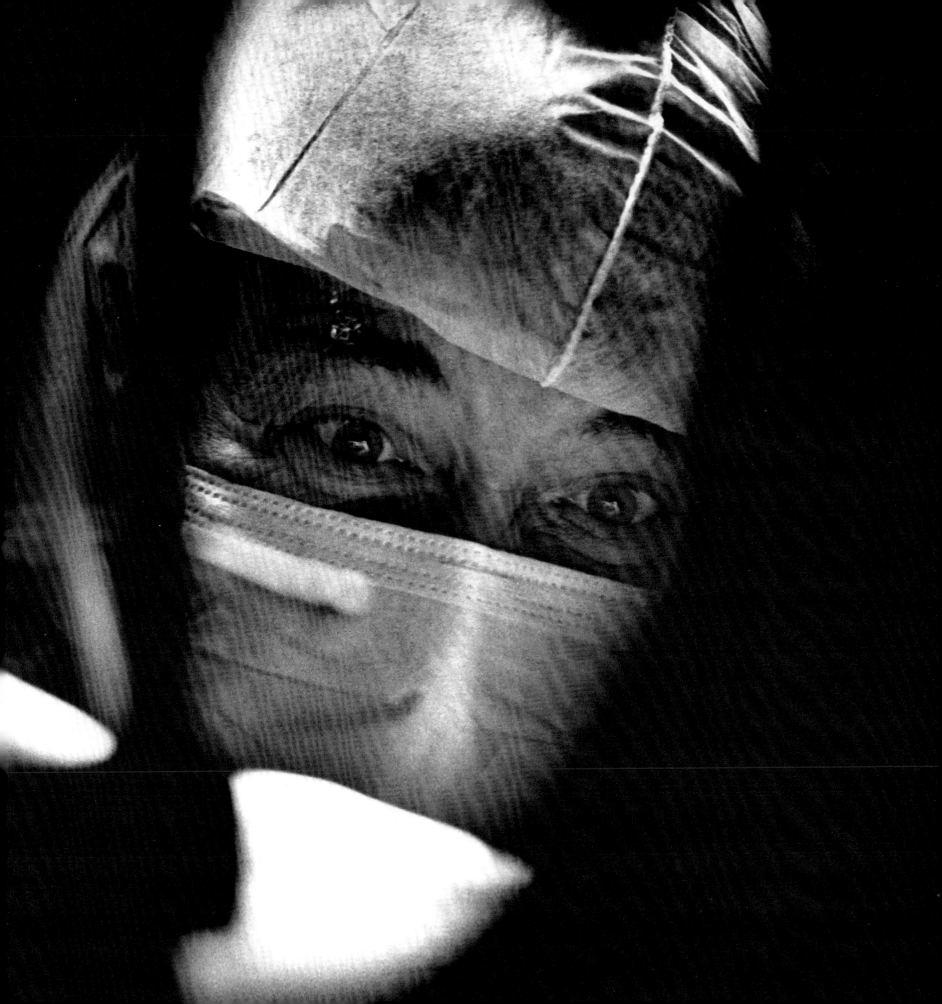

These fellow mortals,
every one, must be
accepted as they are.

George Eliot (Marian Evans Cross)

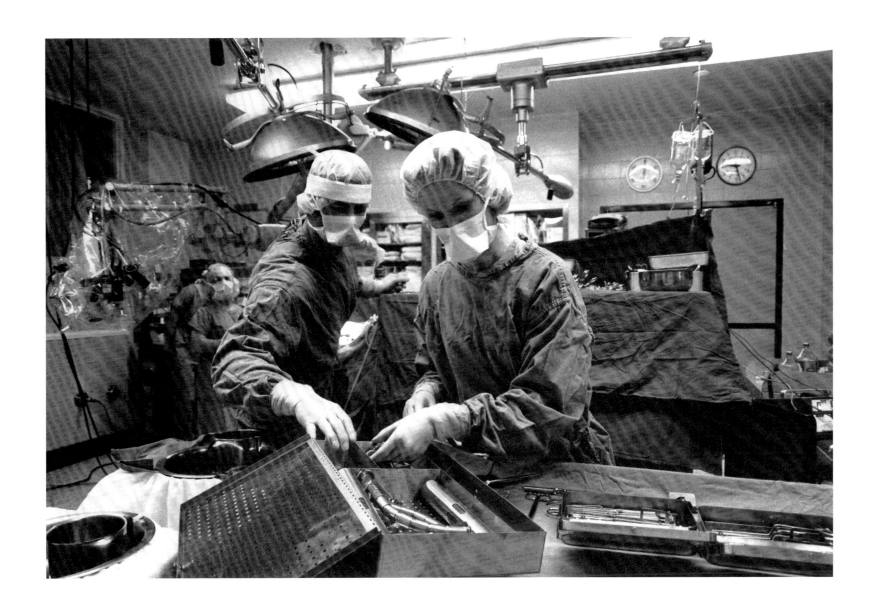

*The medical profession is
a noble and pleasant one,
though laborious and
often full of anxiety.*

Andrew James Symington

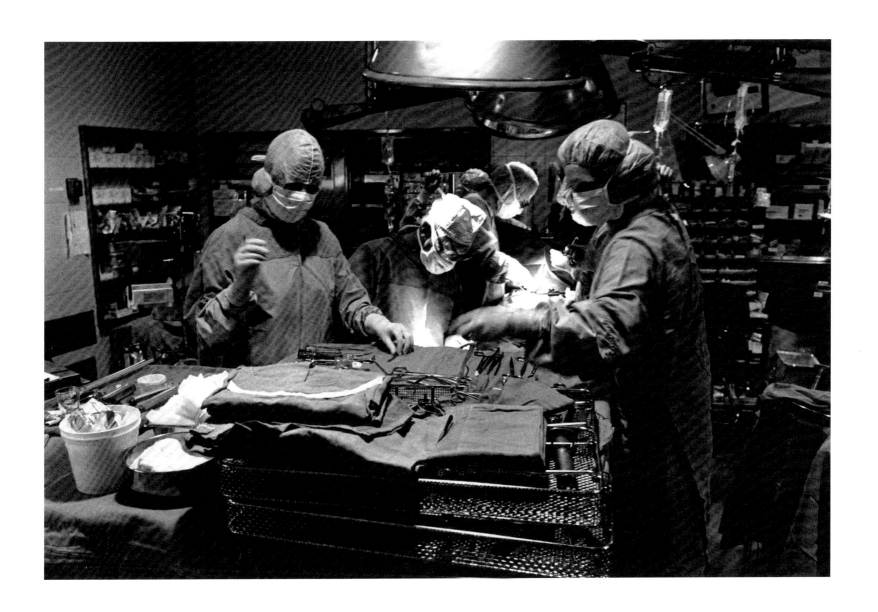

*The operating room
has been twice over
robbed of its terrors.*

Sir William Osler

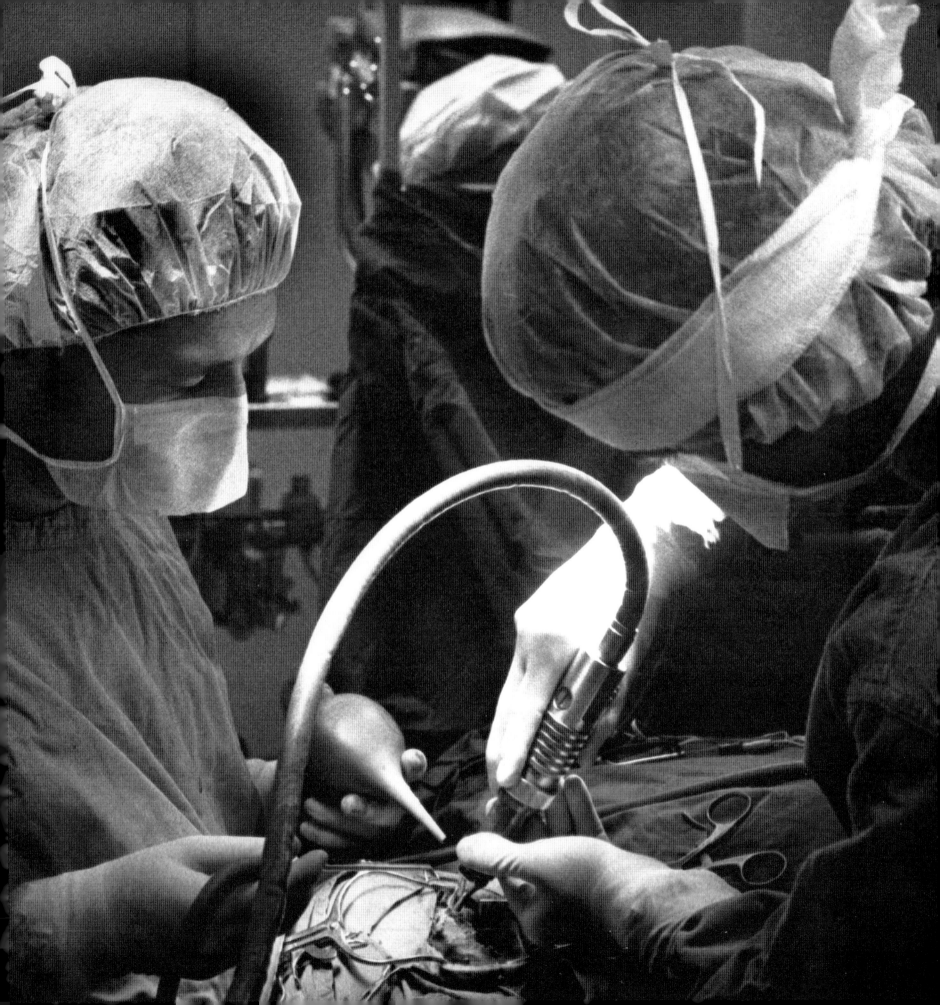

*A calm equanimity is the
desirable attitude.
How difficult to attain,
yet how necessary in
success and failure.*

Sir William Osler

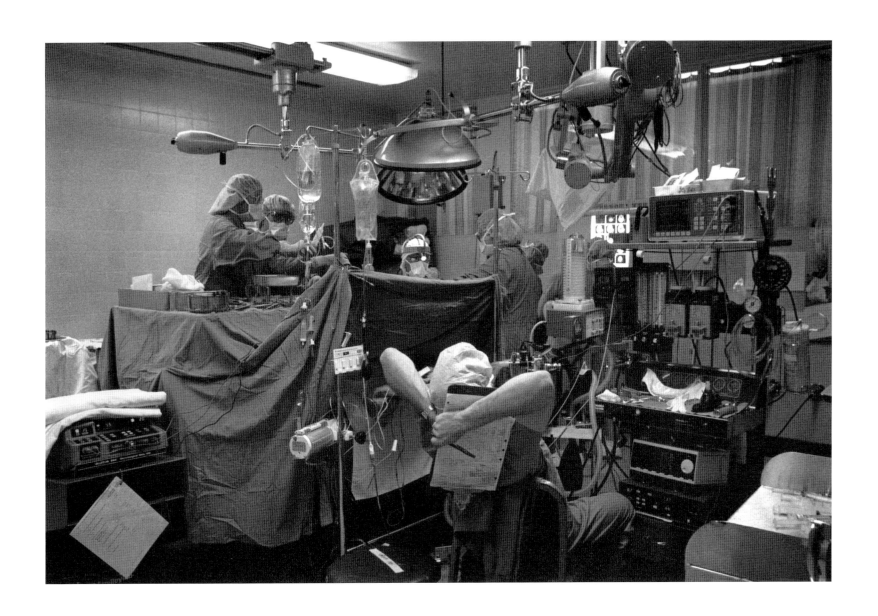

We doctors have always been a simple, trusting folk. Did we not believe Galen implicitly for 1500 years and Hippocrates more than 2000?

Sir William Osler

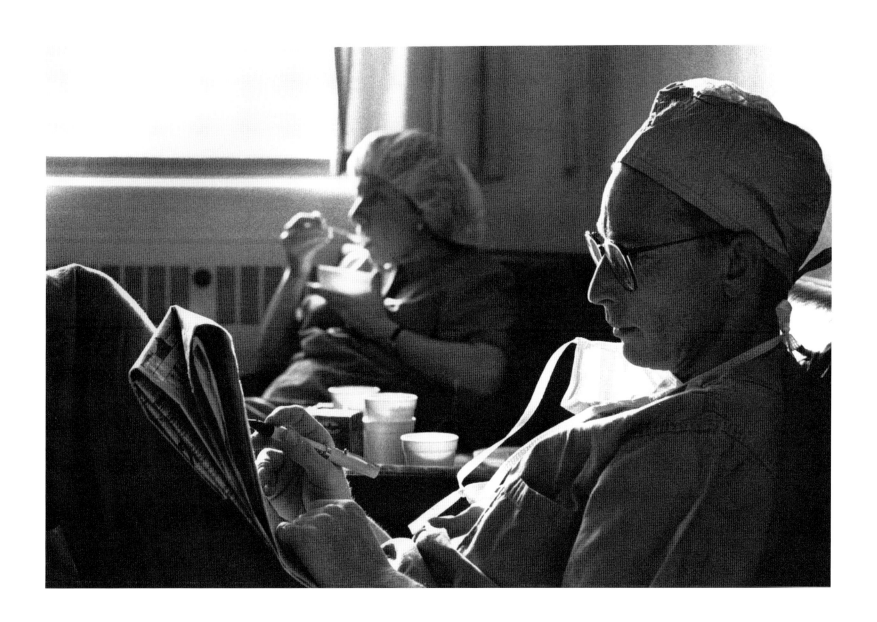

*Faith and knowledge lean
largely upon each other in
the practice of medicine.*

Peter Mere Latham

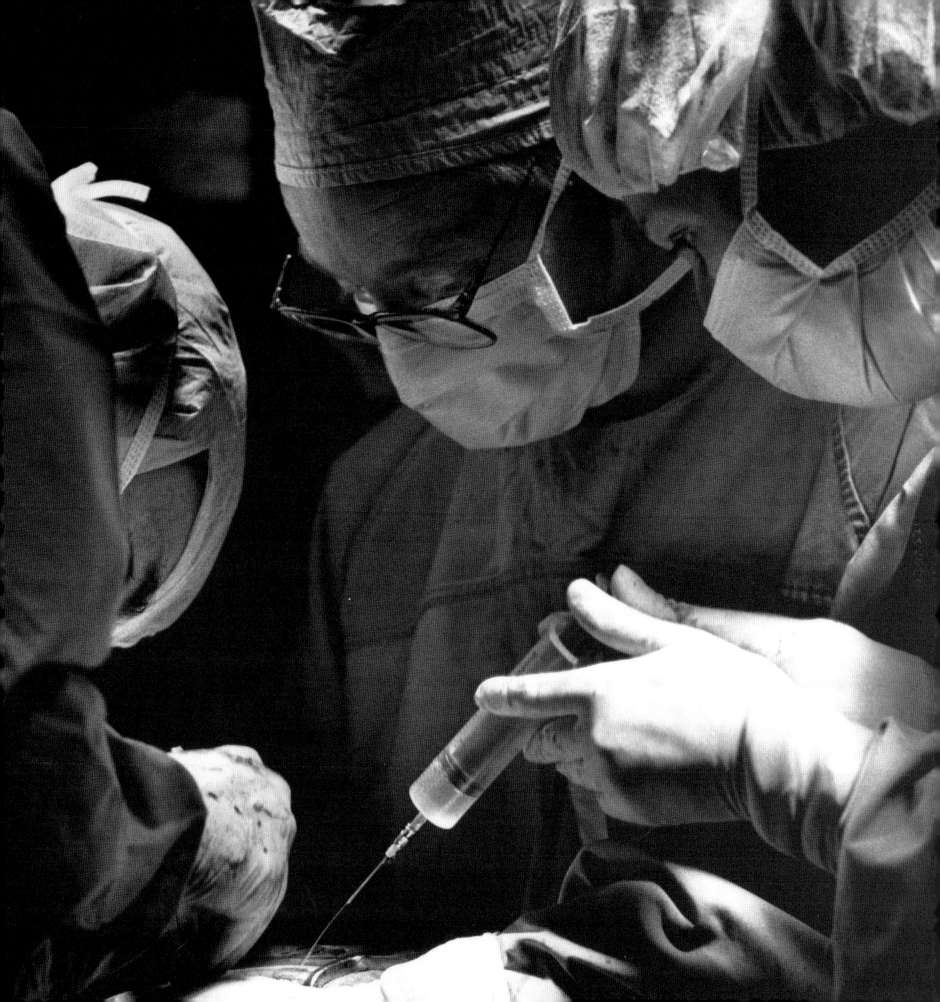

"Talk of patience of Job,"
said a hospital nurse,
"Job was never on night duty."

Stephen Paget

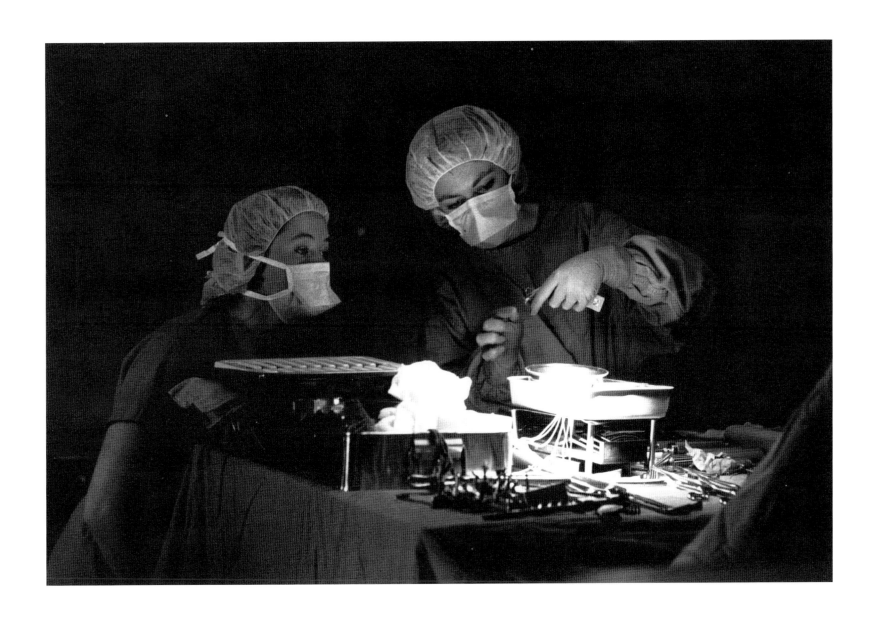

To study the phenomena
of disease without books
is to sail in uncharted
seas, while to study books
without patients is
not to go to sea at all.

Sir William Osler

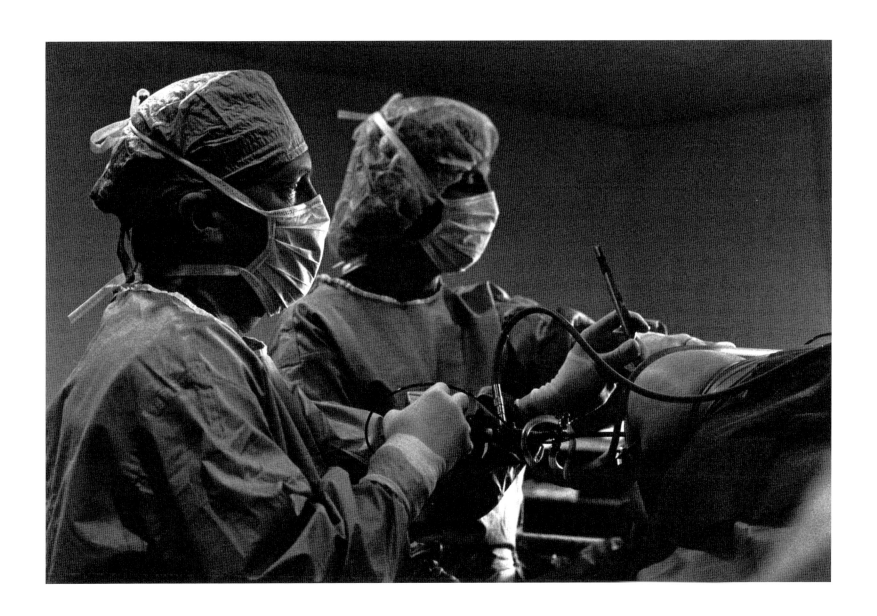

The profession of medicine is distinguished from all others by its singular beneficence.

Sir William Osler

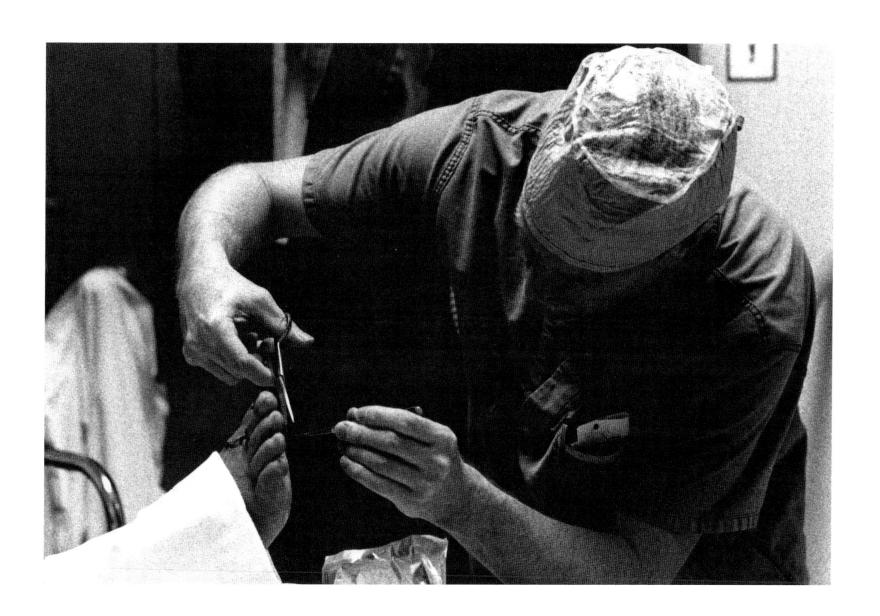

*In the fields of
observation, chance
favours only the mind
that is prepared.*

Louis Pasteur

In seeking absolute truth,
we aim at the unattainable
and must be content with
finding broken portions.

Sir William Osler

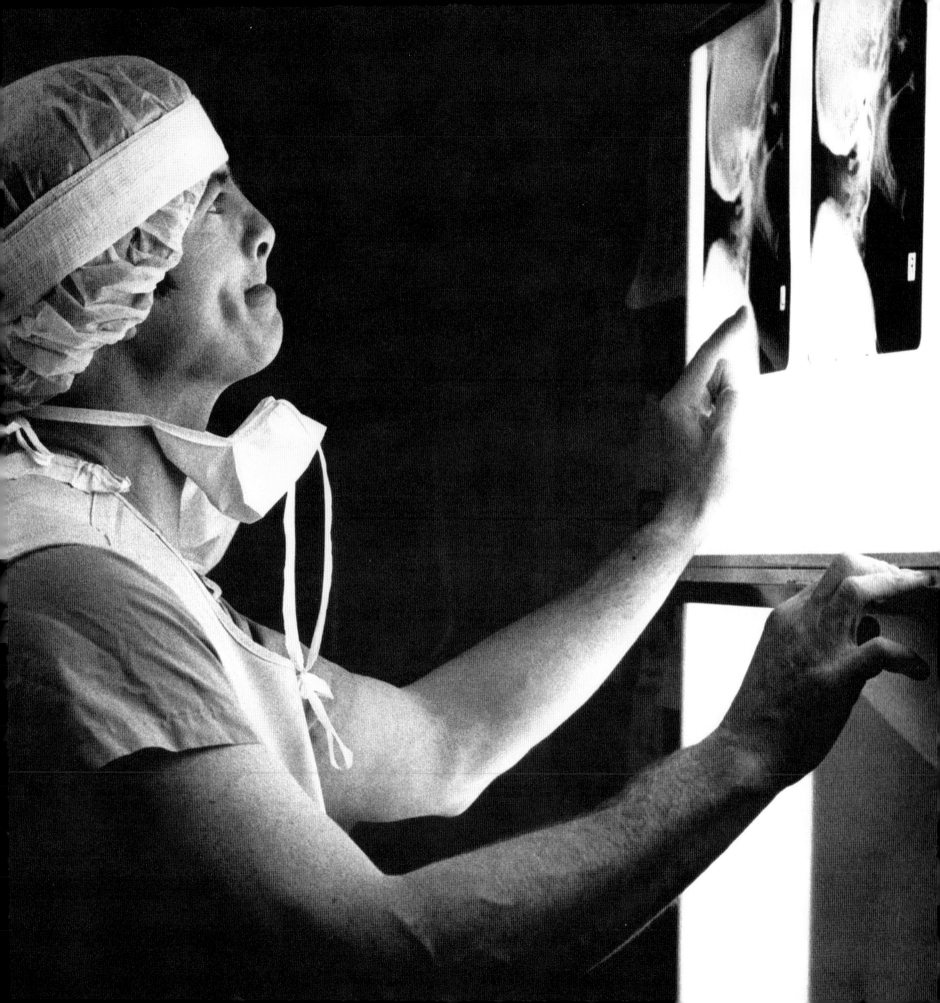

*Nothing in life is more
wonderful than faith –
the one great moving force
which we can neither
weigh in the balance nor
test in the crucible.*

Sir William Osler

*The most important
person in the operating
theatre is the patient.*

Russell John Howard

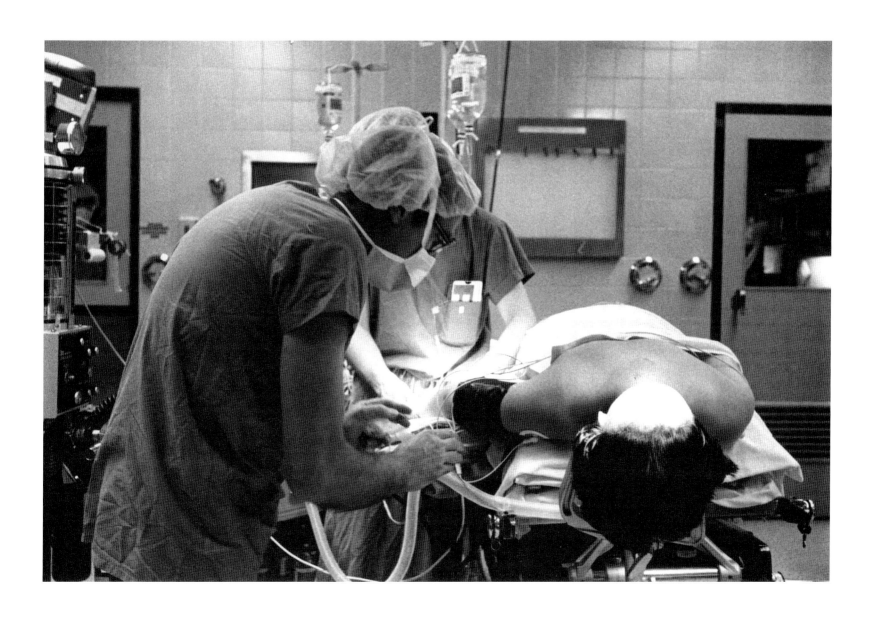

*Certainly you have made
the practice of medicine
easier to the physician.*

Sir William Osler

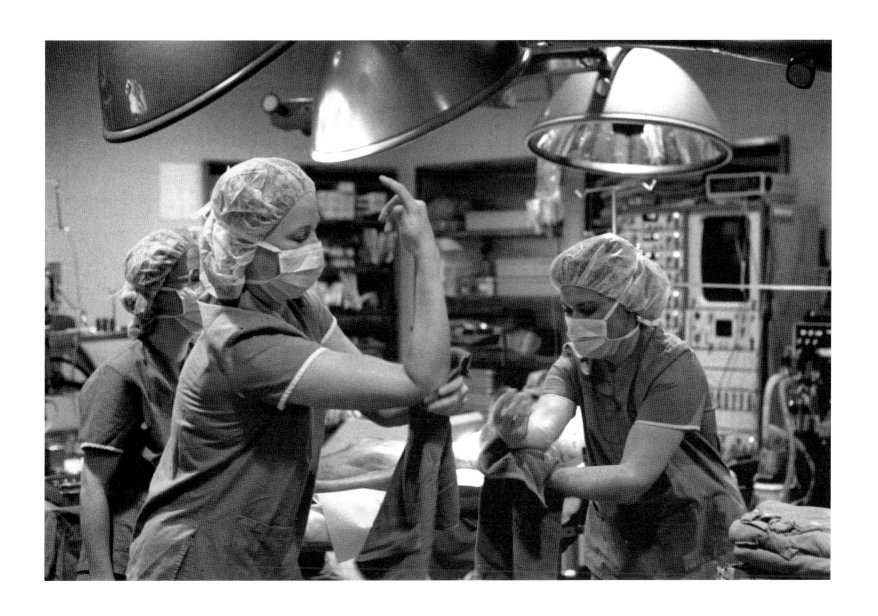

*Soap and water and
common sense are
the best disinfectants.*

Sir William Osler

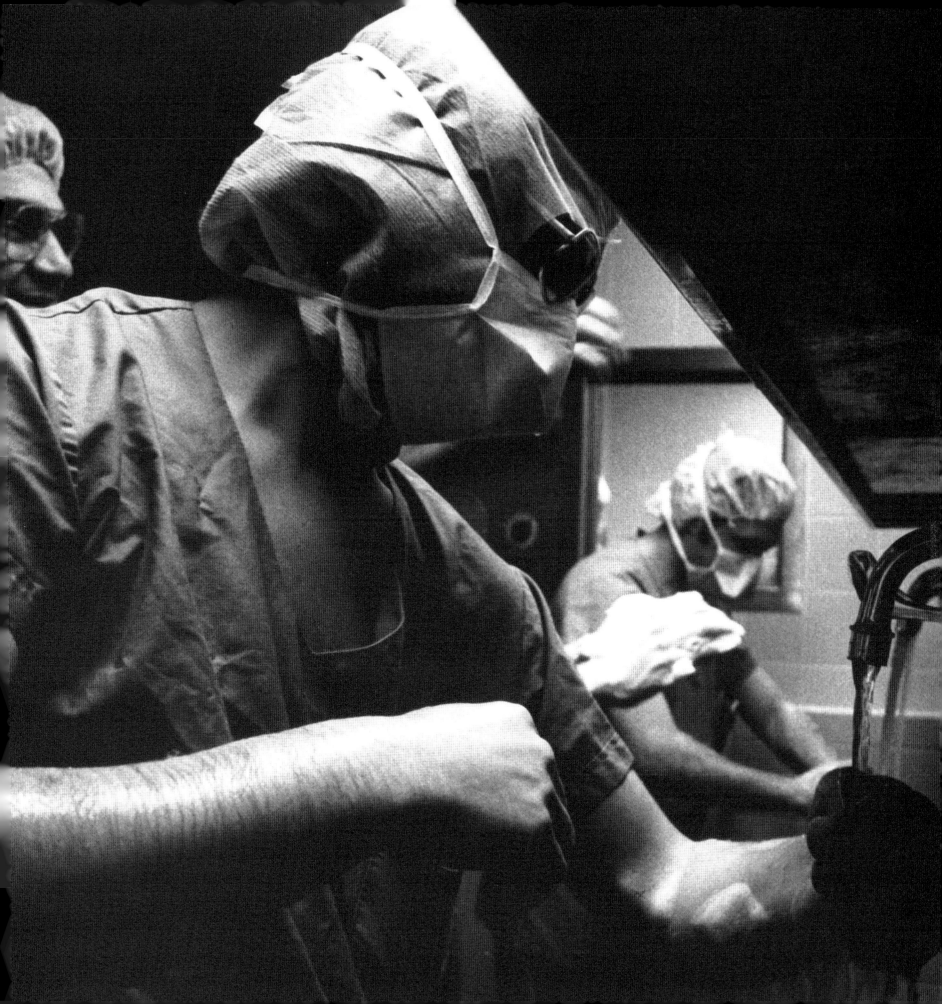

*To the love of his
profession the physician
should add a love of
humanity.*

Hippocrates

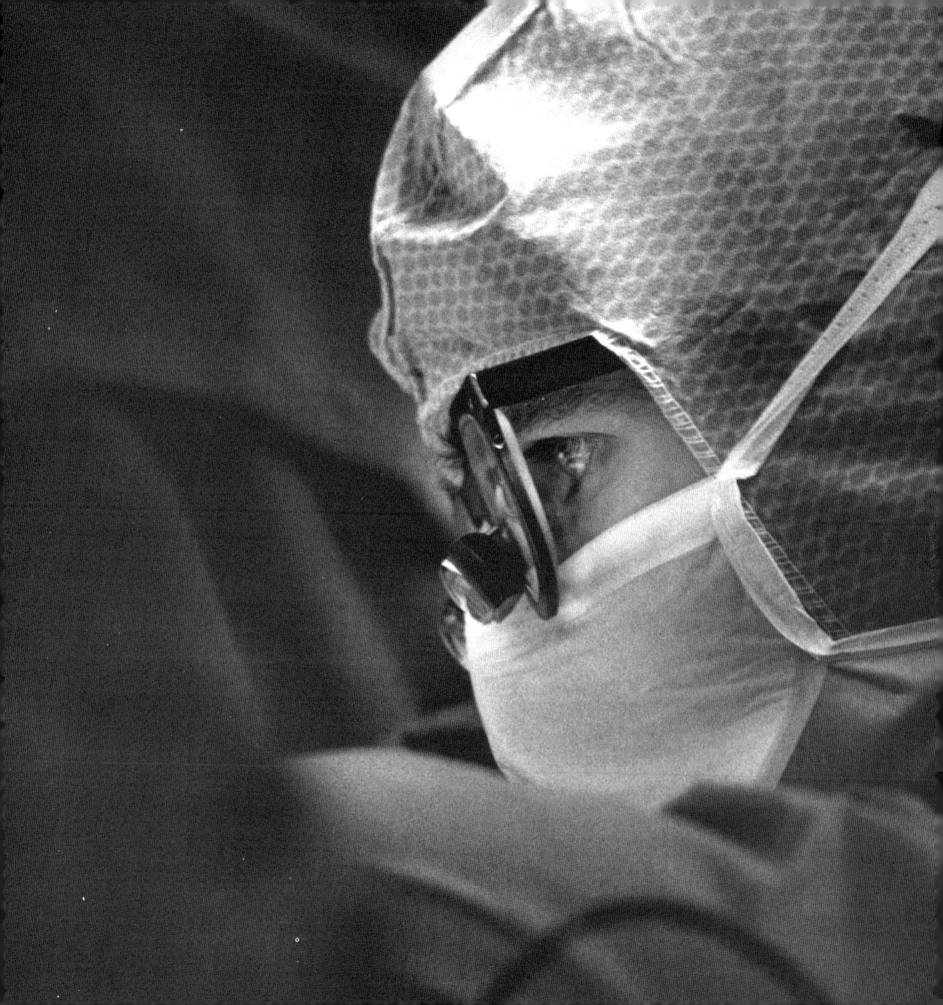

*A surgeon should be
youthful with strong
and steady hand.*

Celsus

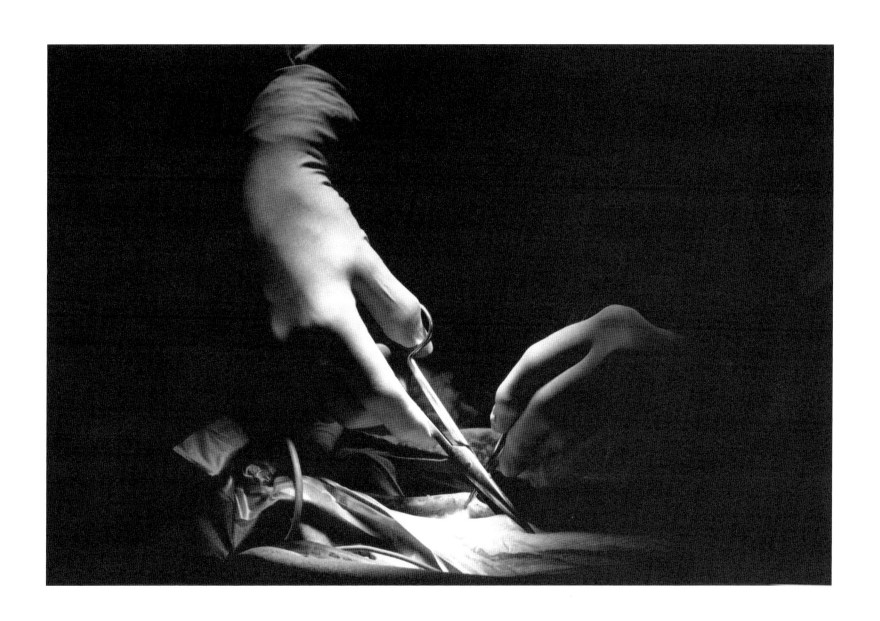

The master word in medicine is work.... Though a little one it looms large in meaning.

Sir William Osler

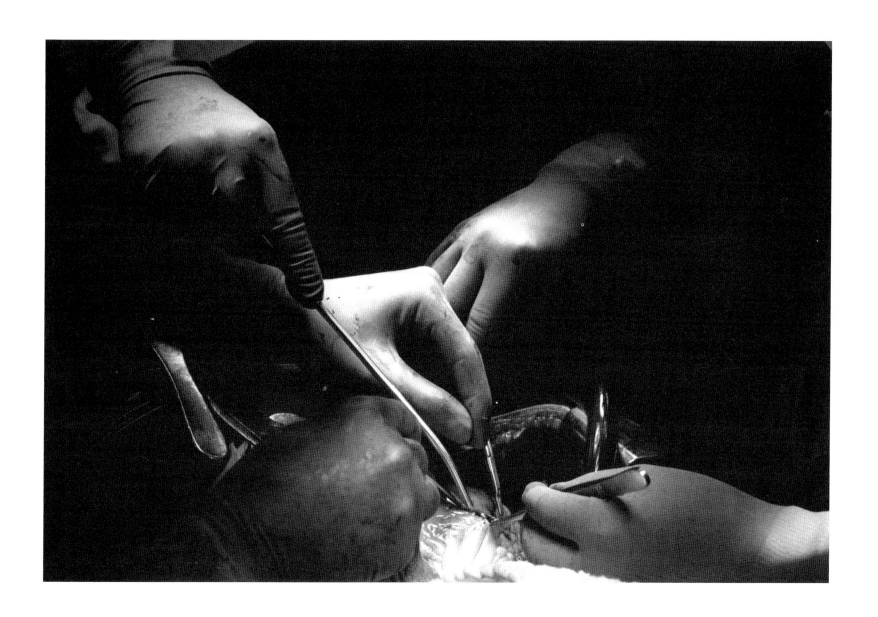

*Empyema needs a surgeon
and three inches of cold
steel instead of a fool
of a physician.*

Sir William Osler

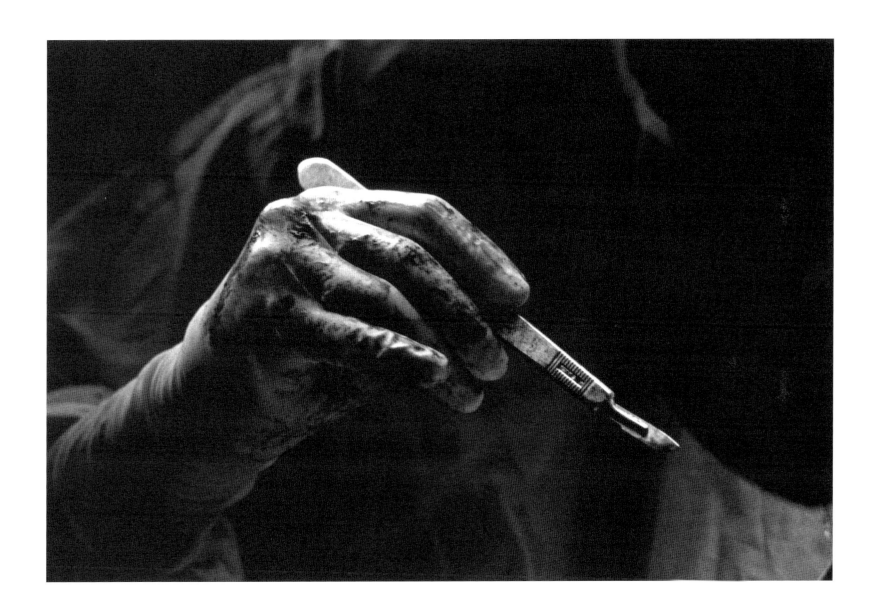

Blessed are they
who find their work;
let them ask no other
blessedness.

Thomas Carlyle

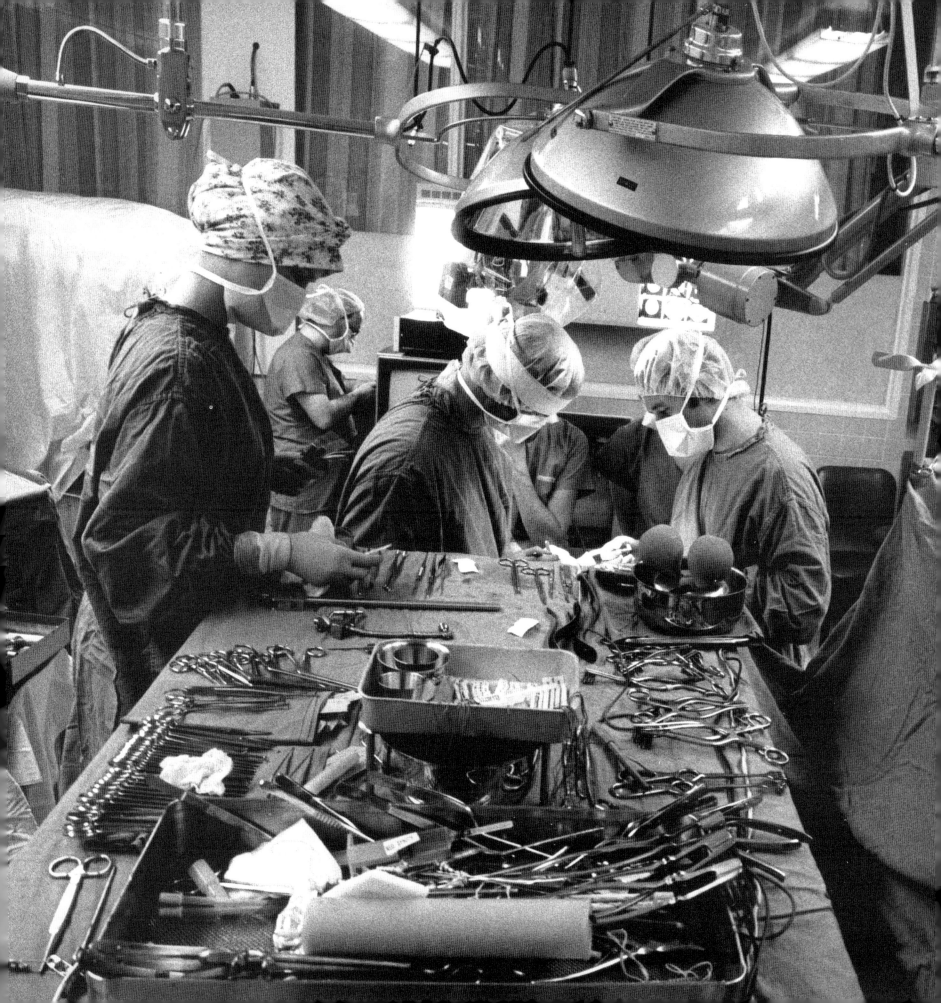

Let each day's work
absorb your entire
energies and satisfy your
widest ambition.

Sir William Osler

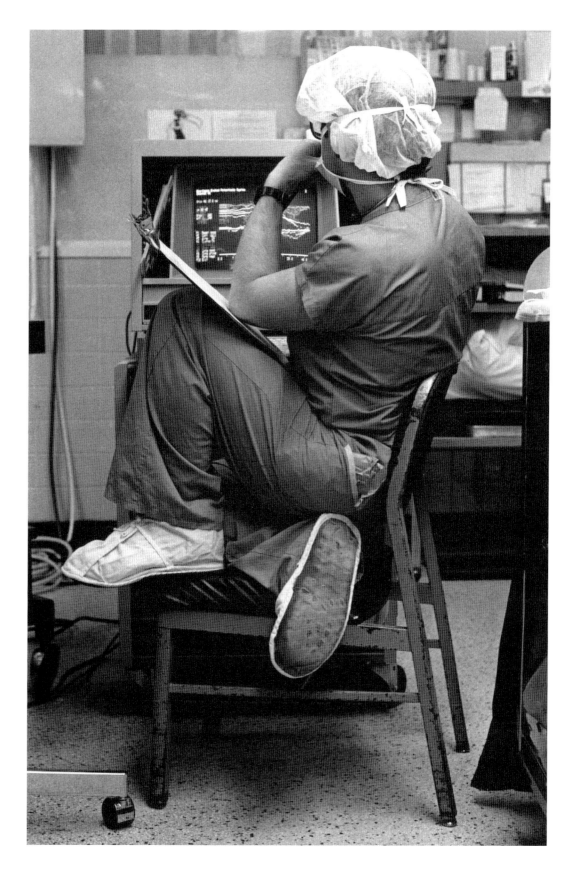

*For the difficult surgery
of today, a sturdy pair
of legs is also an
indispensable necessity!*

Owen H. Wangensteen

Do not worry about your future, care for nothing but the matter at hand.

Sir William Osler

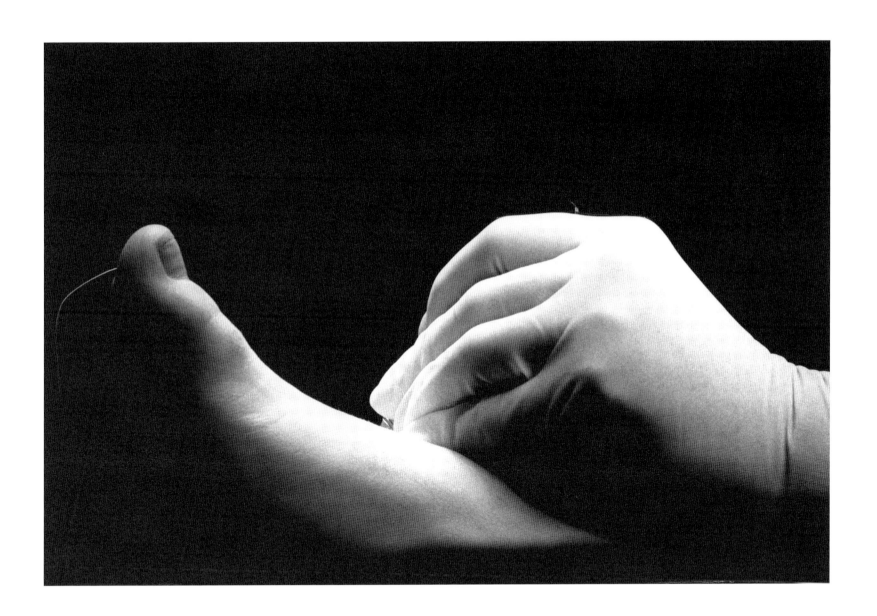

I love doctors and hate
their medicine.

Walt Whitman

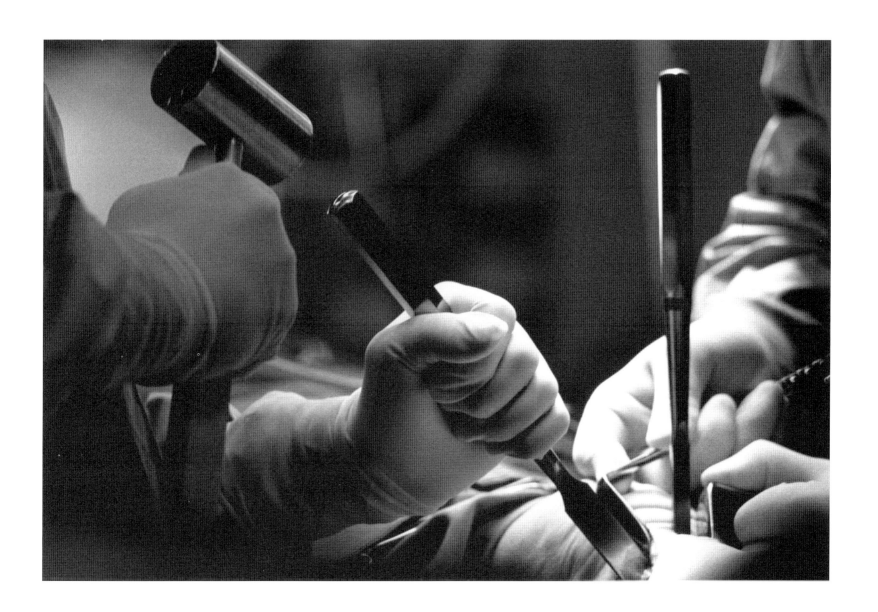

*It is the human touch
that counts for most
in our relation with
our patients.*

Robert Tuttle Morris

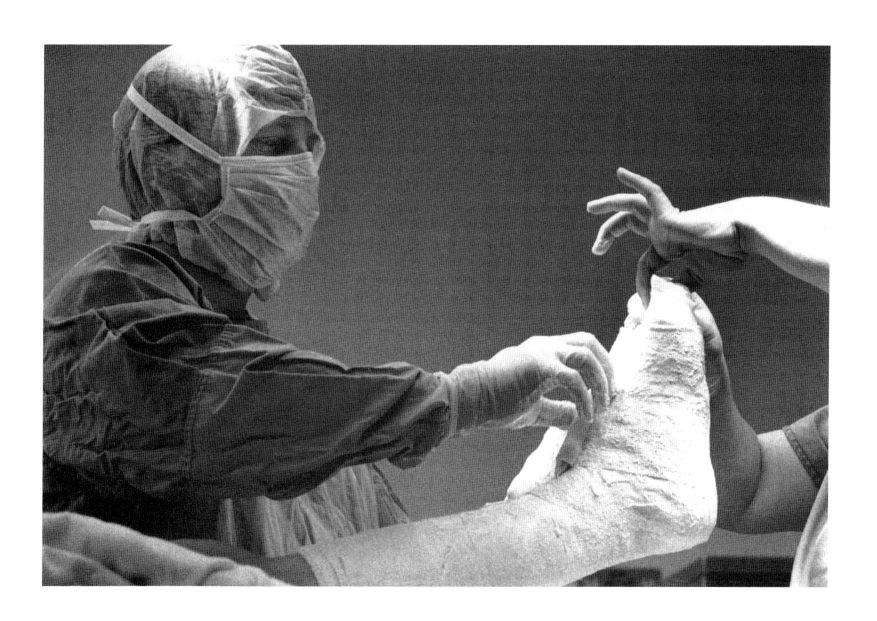

*The physician is
Nature's assistant.*

Galen

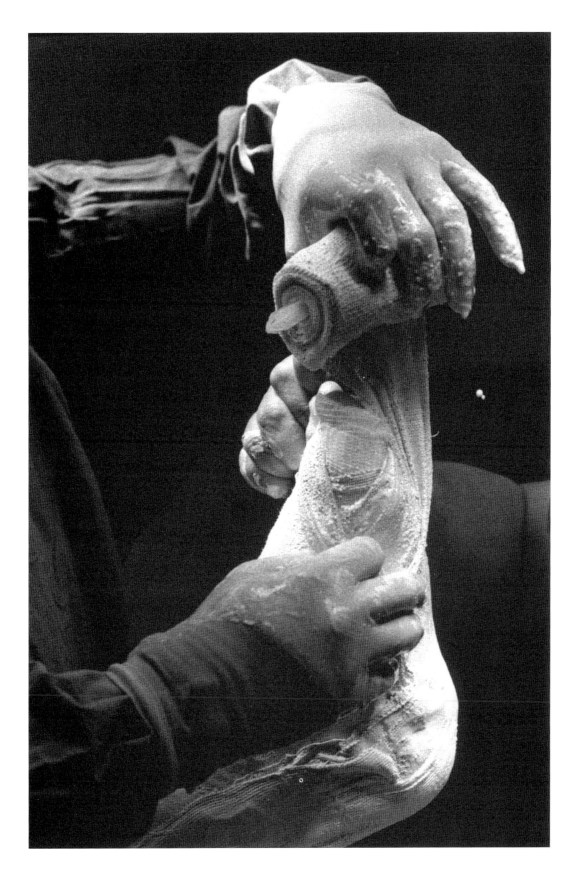

*Surgery is the ready
motion of steady and
experienced hands.*

Galen

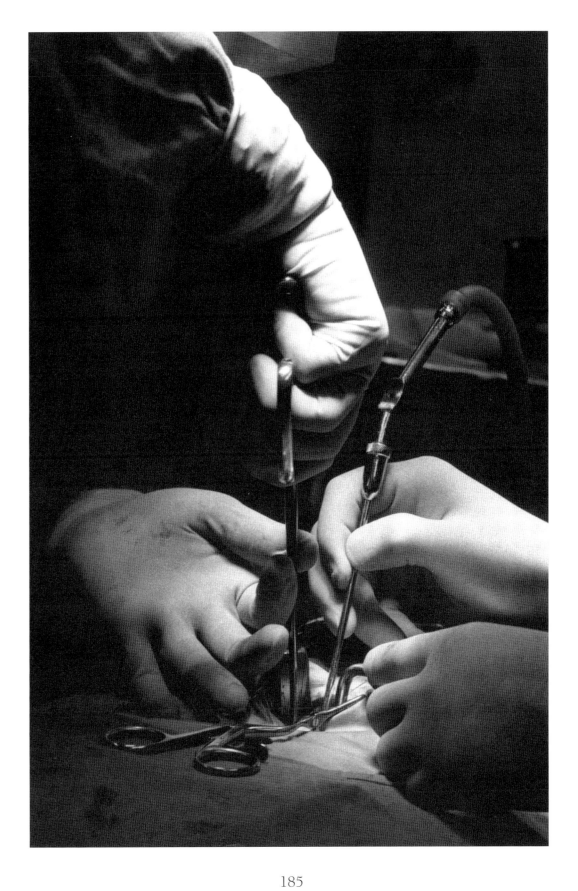

No matter how trifling the matter at hand, do it with a feeling that it is the best that is in you.

Sir William Osler

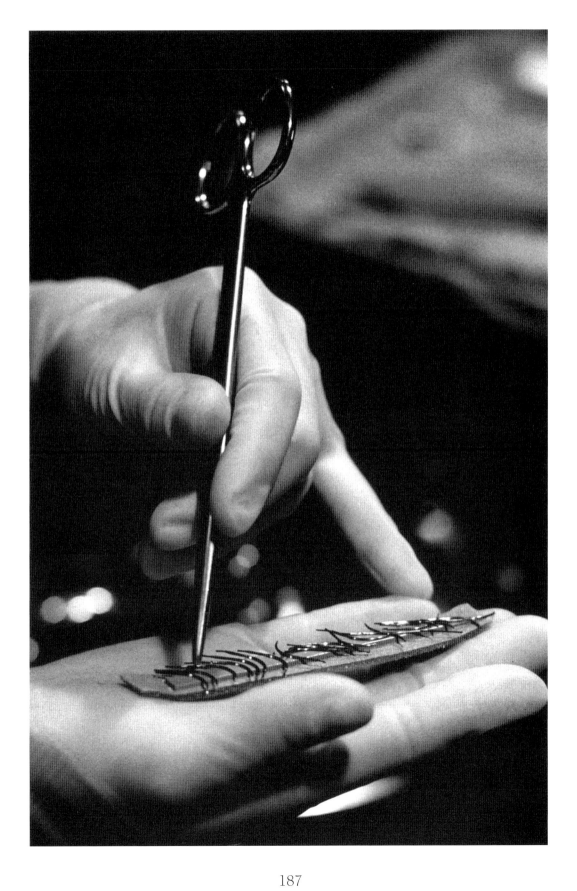

*A small hurt in the eye
is a great one.*

Old English Proverb

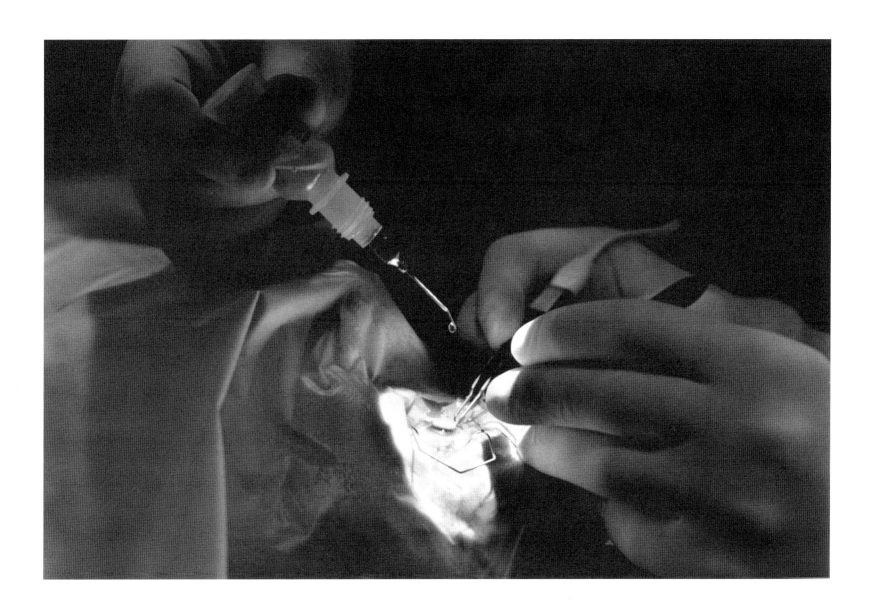

To prevent disease,
to relieve suffering
and to heal the sick –
this is our work.

Sir William Osler

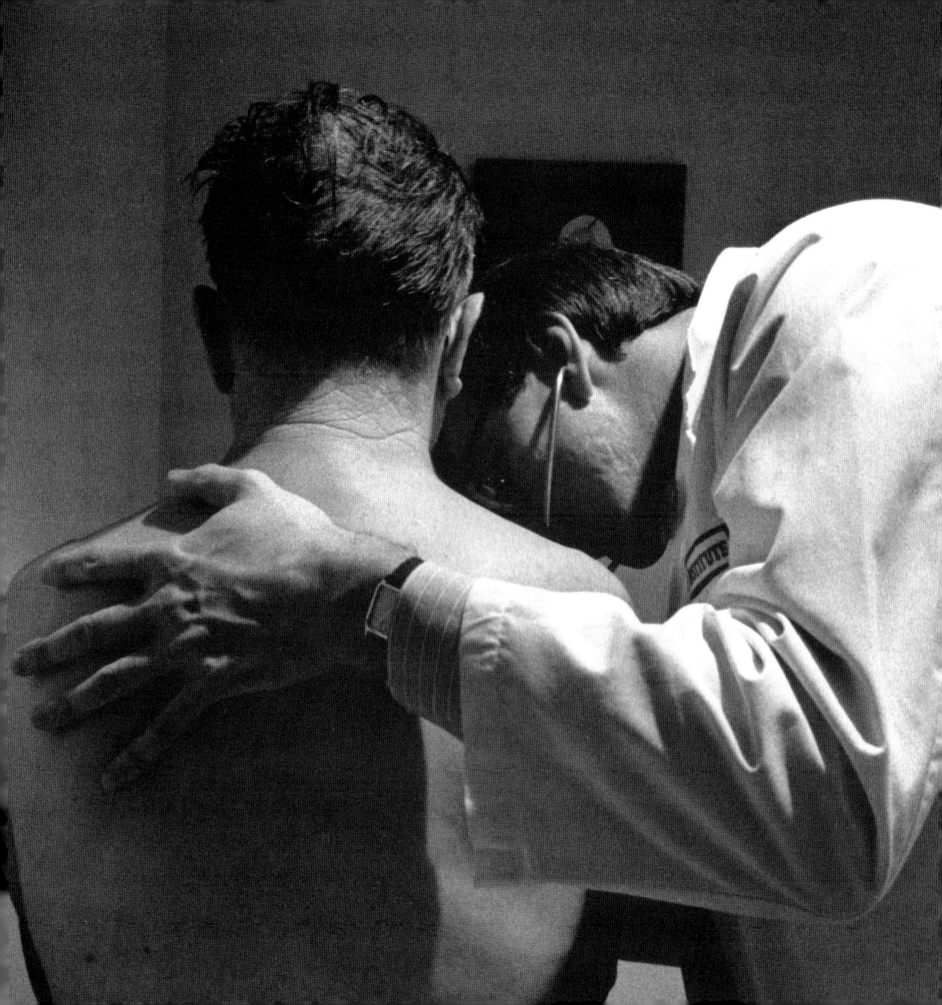

Let us accept truth,
even when it surprises us
and alters our views.

George Sand (Amandine Aurore Lucie Dupin)

*To know just what has to
be done, then to do it,
comprises the philosophy
of practical life.*

Sir William Osler

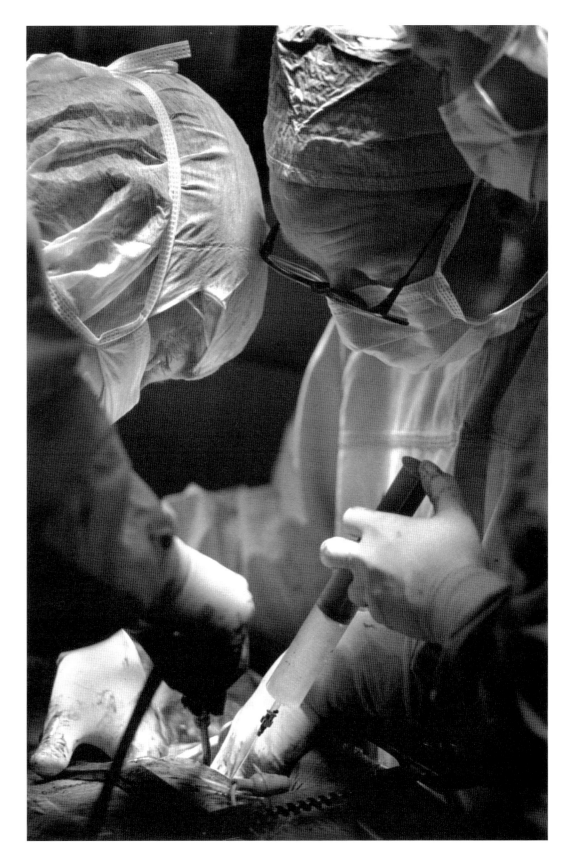

In medicine rules are absolute but consequences are variable.

Celsus

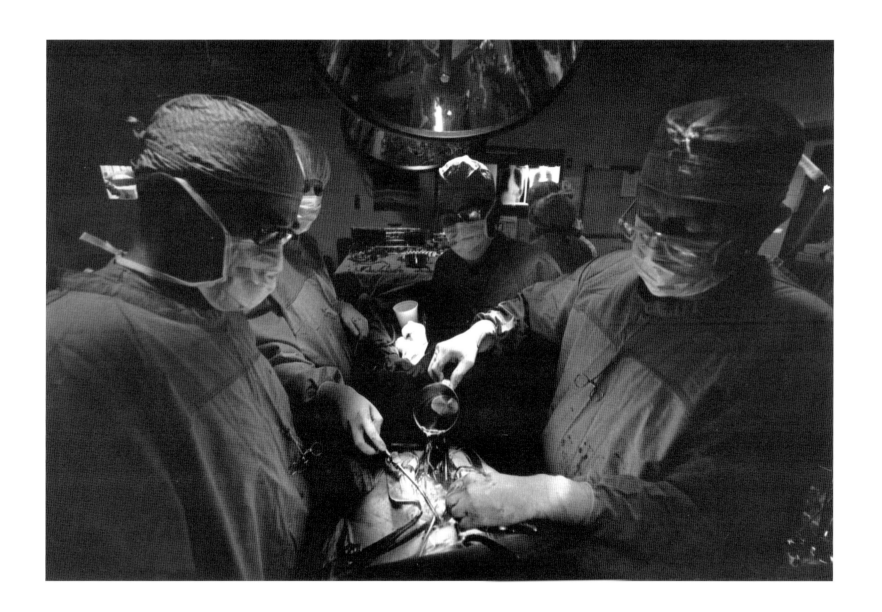

The ideal doctor
is patient.

Robert Haven

Fifteen minutes at the bedside is better than three hours at the desk.

Sir William Osler

*Is there anything more
doleful than three or four
physicians entering a
patient's room?*

Sir William Osler

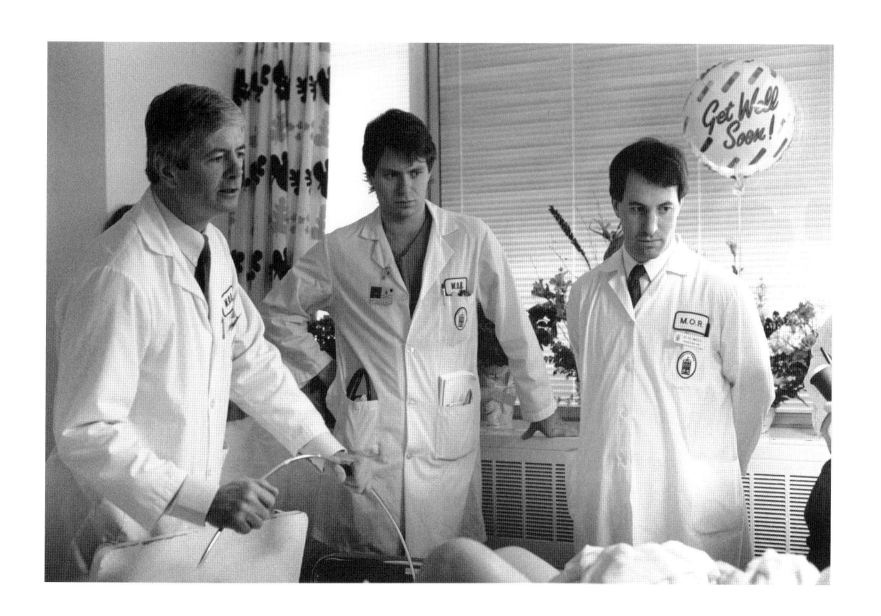

*Acquire the
art of detachment,
the virtue of method and
the quality of thoroughness,
but above all,
the grace of humility.*

Sir William Osler

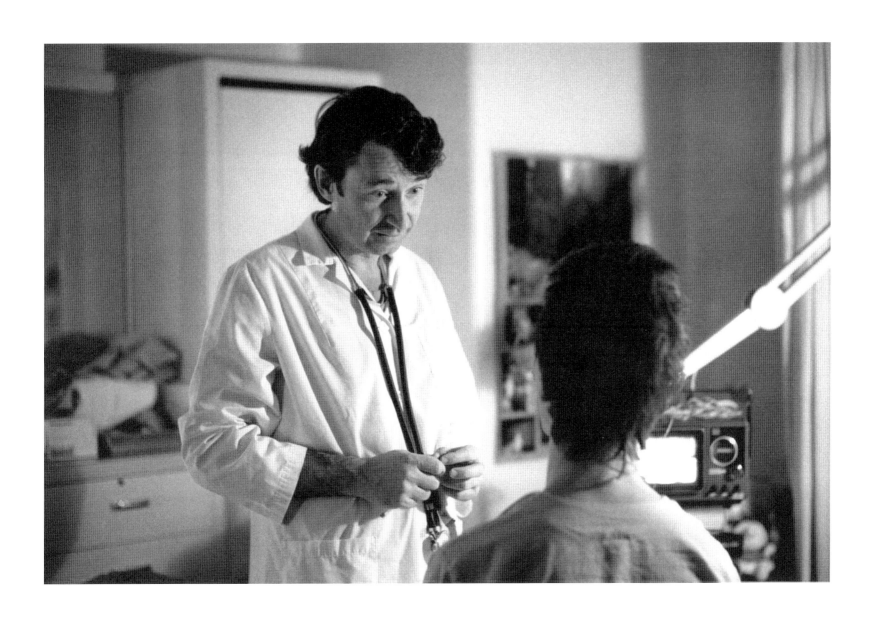

Taking a patient's hand
gives him confidence
in his physician.

Sir William Osler

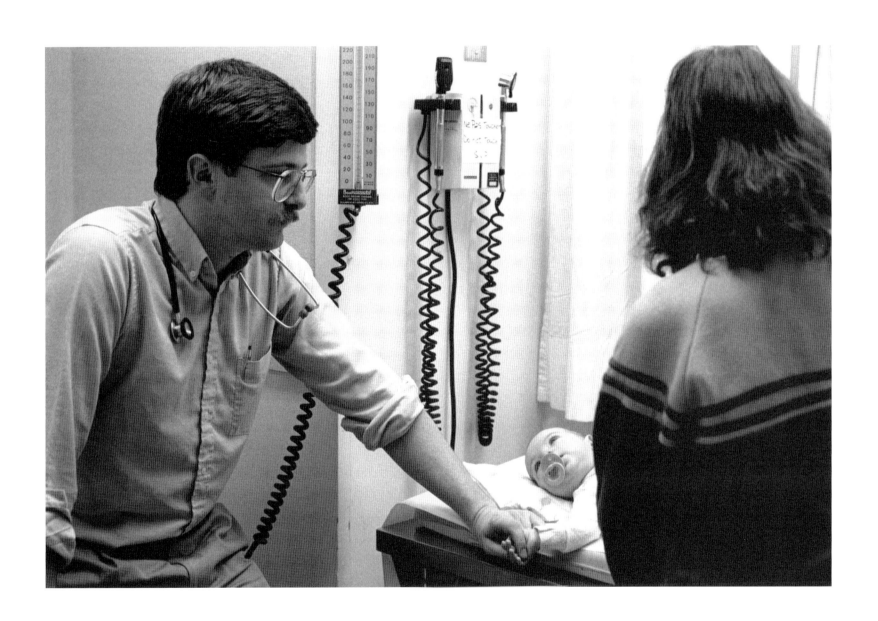

*Medicine is the only
world-wide profession,
following everywhere
the same methods,
actuated by the same
ambitions and pursuing
the same ends.*

Sir William Osler

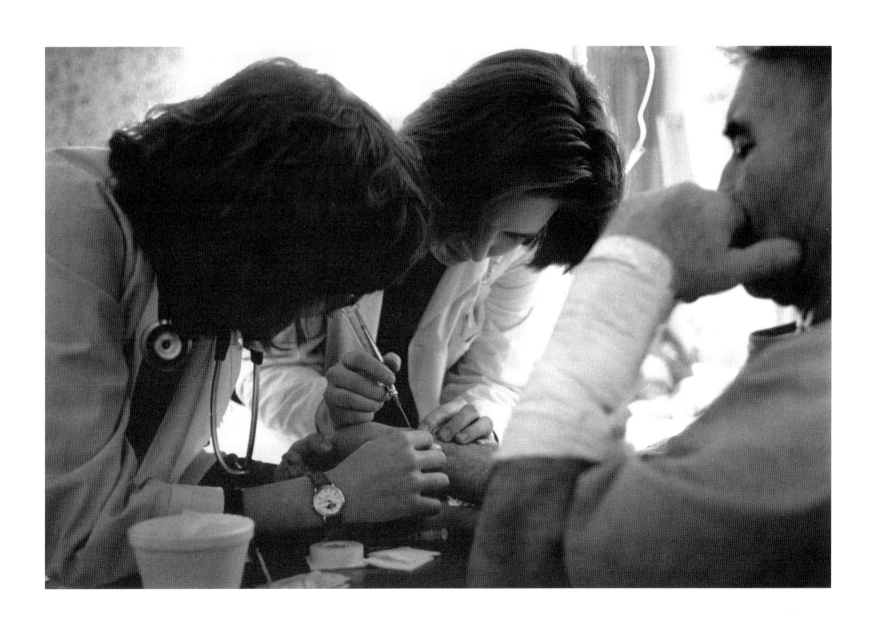

215

To cure sometimes,
to relieve often,
to comfort always.

Anonymous

*In illness, the physician is
a father; in convalescence,
a friend; when health is
restored, he is a guardian.*

Brahmanic Saying

*Work today and be happy
tomorrow – that's the
physician's rule of life.*

Wilder Penfield

Faith is the first factor in
a life devoted to service.
Without faith,
nothing is possible.
With it, nothing is
impossible.

Mary McLeod Bethune

*Imperturbability means
coolness and presence
of mind under all
circumstances.*

Sir William Osler

*Only those who regard
healing as the ultimate
goal can, therefore,
be designated as
physicians.*

Rudolf Virchow

Common sense in medicine is the master workman.

Peter Mere Latham

Where did you come
from, baby dear?
Out of everywhere
into here.

George MacDonald

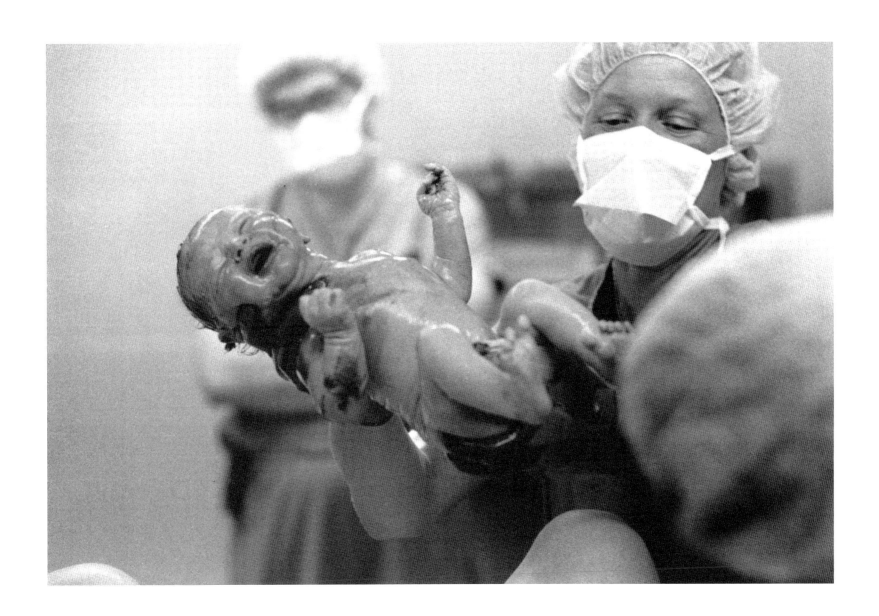

*The physician needs
a clear head
and a kind heart.*

Sir William Osler

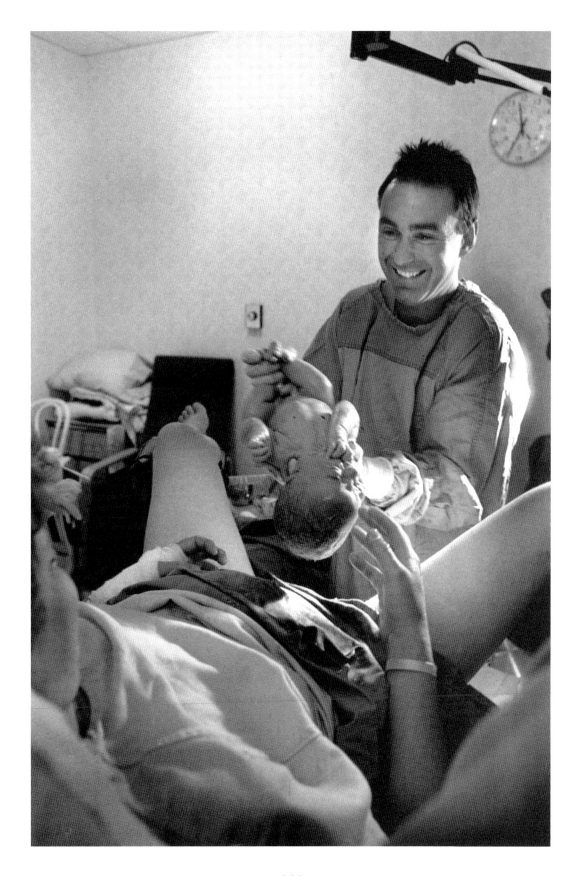

233

Anaesthetics and antiseptics have manacled the demon pain, and the curse of travail has been lifted from the soul of woman.

Sir William Osler

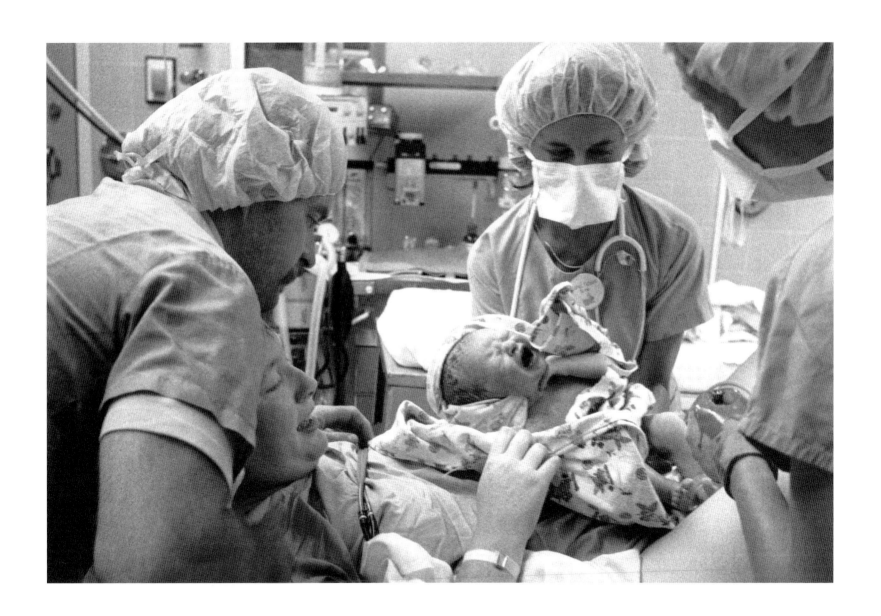

*It is worthwhile to secure
the happiness of the
patient.*

William J. Mayo

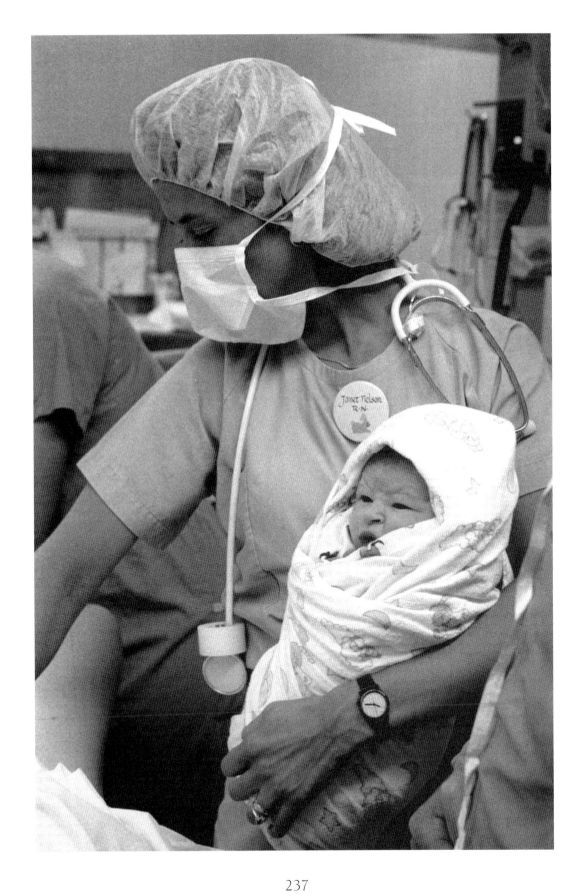

All my life through,
the new sights of Nature
made me rejoice
like a child.

Marie Curie

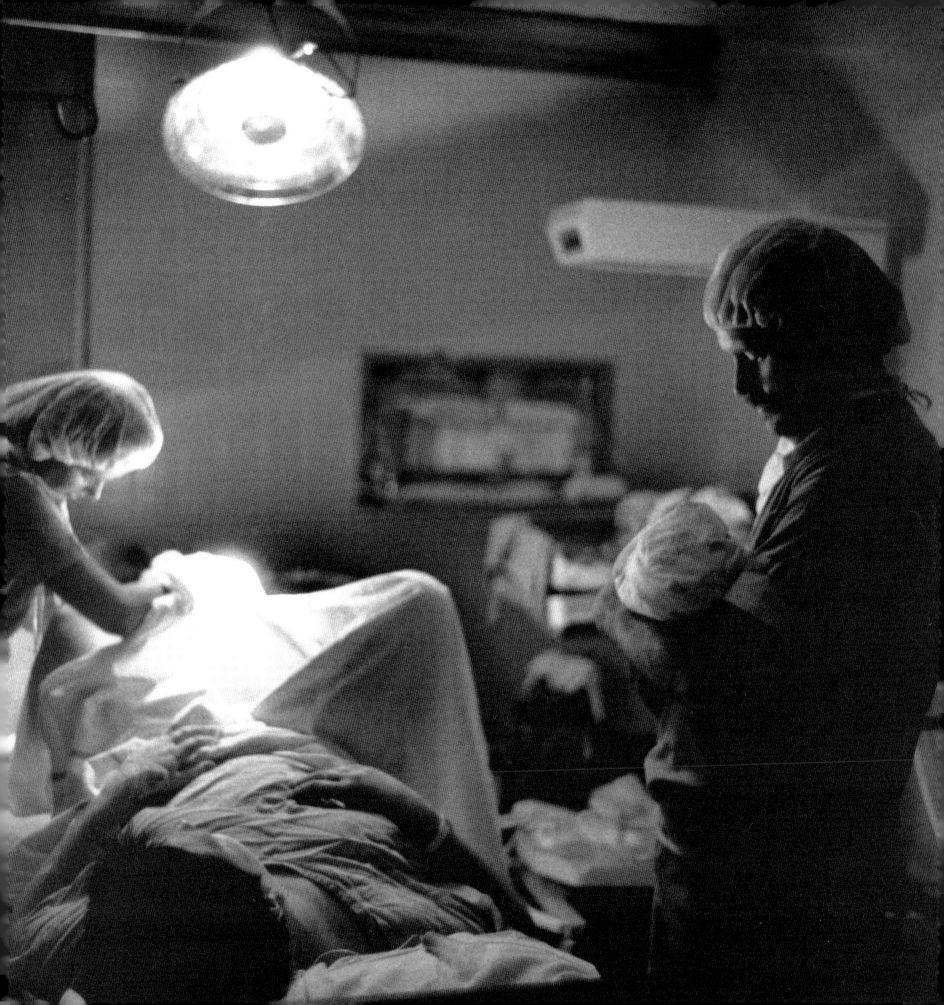

It is a wise father that
knows his own child.

William Shakespeare

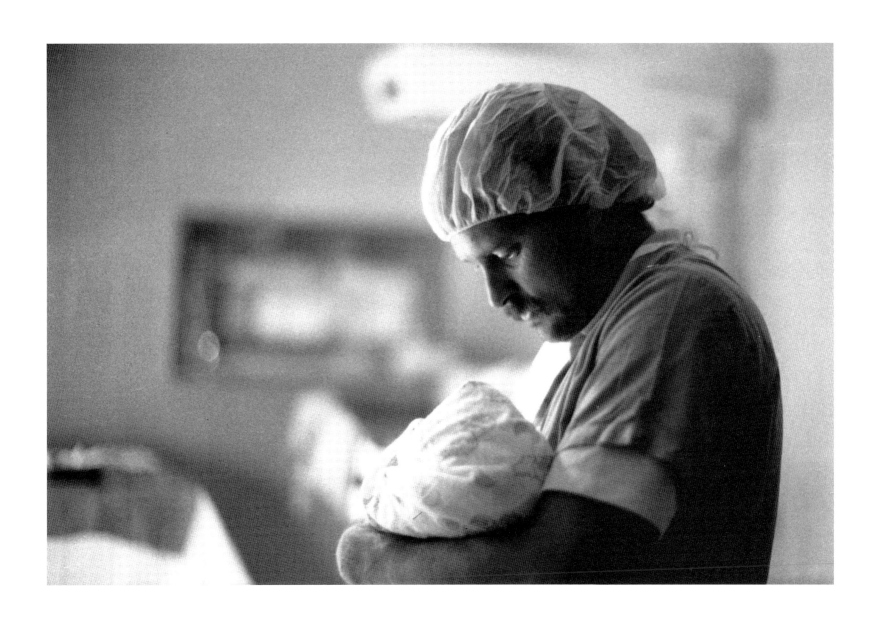

*The cultivated
general practitioner –
may this be the destiny
of a large majority of you!
You cannot reach any better
position in a community.*

Sir William Osler

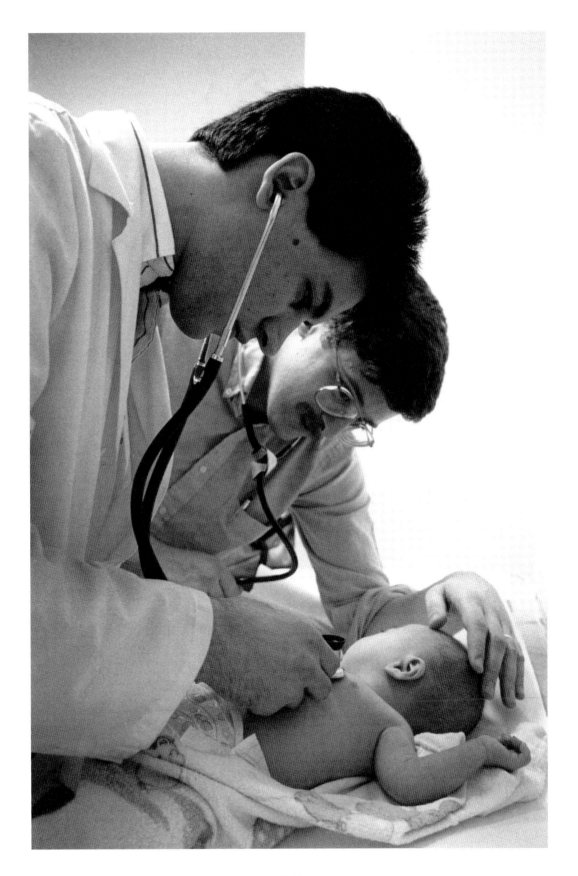

When listening to heart murmurs you must tune up your auditory hair cells and flatten out your Pacinian corpuscles.

Sir William Osler

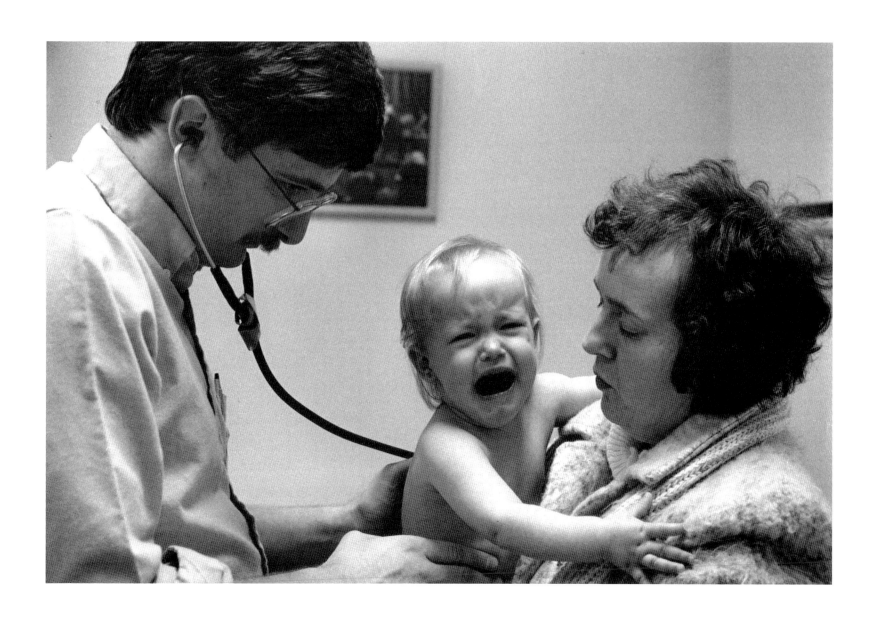

*Care more particularly
for the individual patient
than for the special
features of the disease.*

Sir William Osler

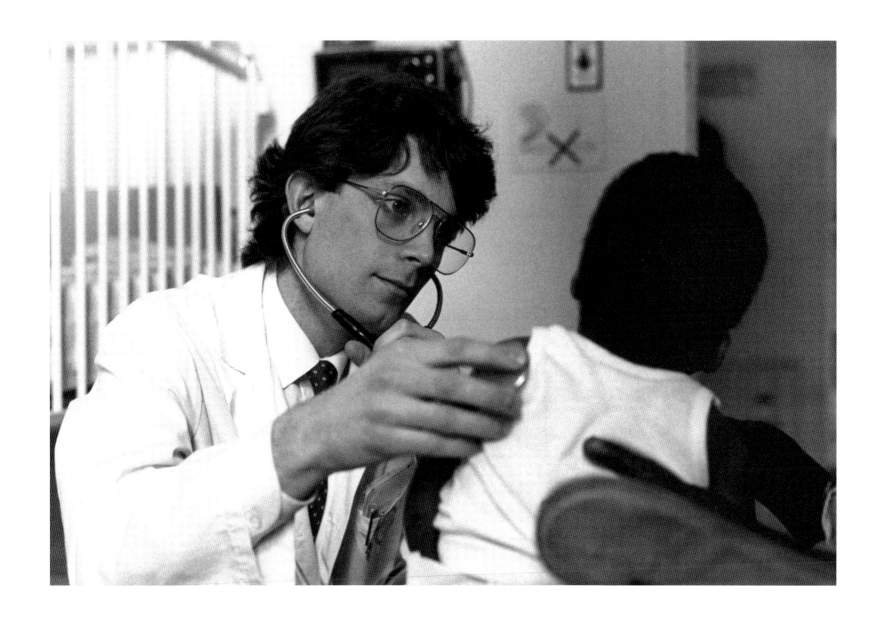

Happiness lies in the absorption in some vocation which satisfies the soul.

Sir William Osler

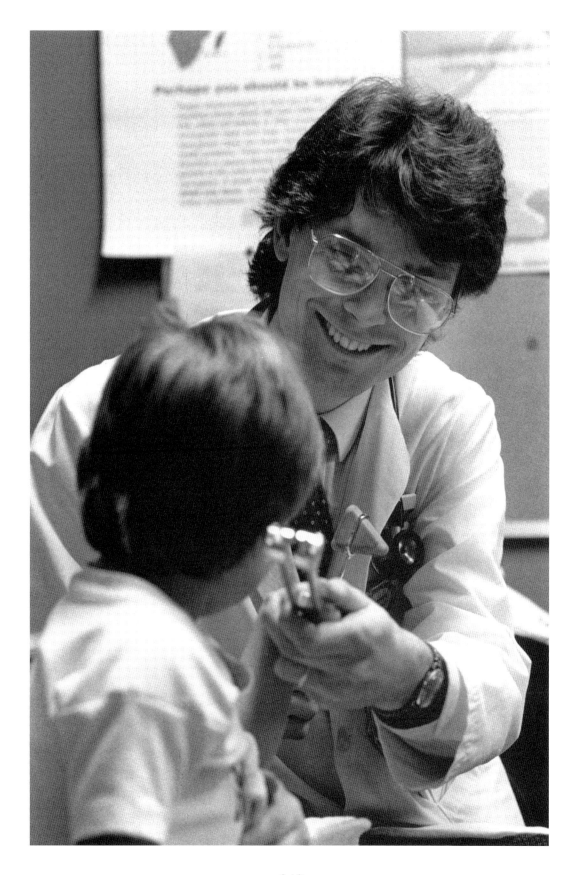

Happiness is your profession.

Sir William Osler

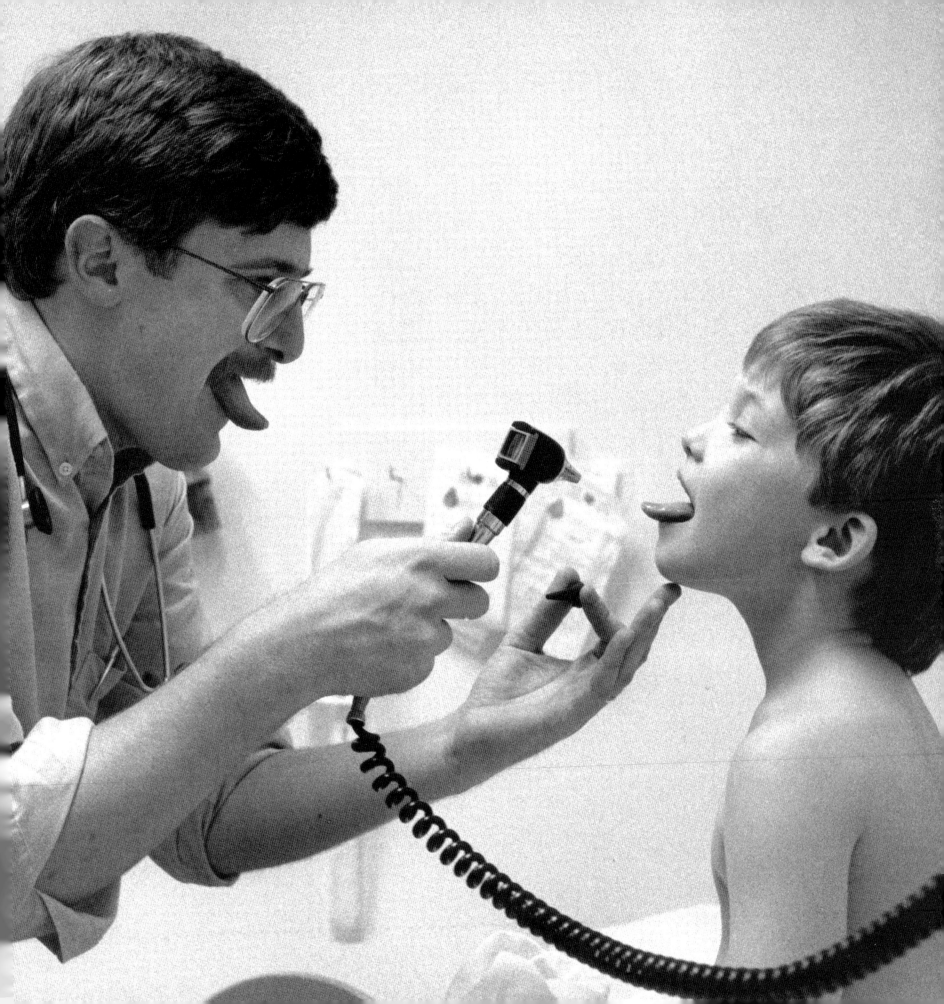

To have striven,
to have made an effort,
to have been true to
certain ideals –
this alone is worth
the struggle.

Sir William Osler

I try to work as the invisible man and not be part of the story I am documenting. Let those you are photographing do their job and find the pictures in what they are doing without interfering.

Ted Grant

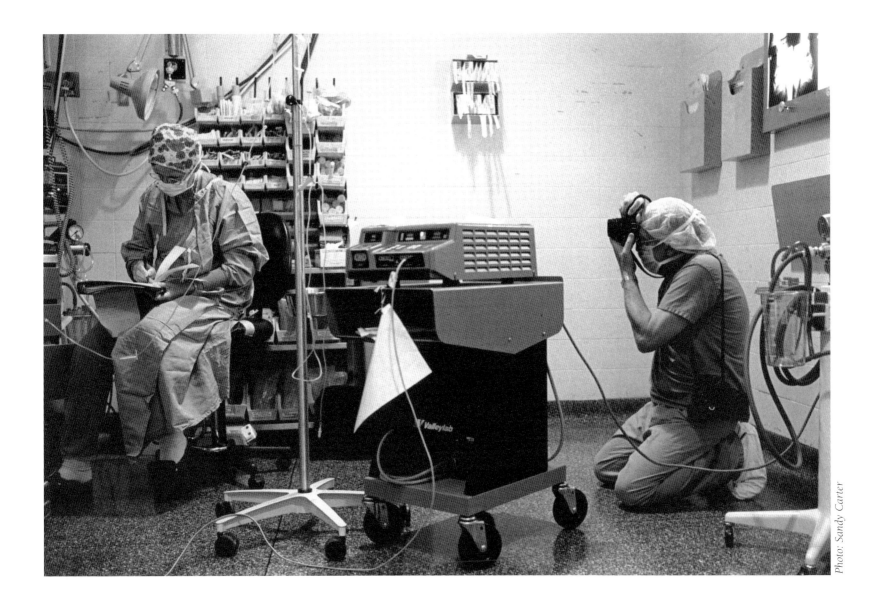

Index